IMAGES
of America

SUMMIT COUNTY

IMAGES
of America

SUMMIT COUNTY

Sandra F. Mather, Ph.D.,
and the Summit Historical Society

ARCADIA
PUBLISHING

Published by Arcadia Publishing
Charleston SC, Chicago IL, Portsmouth NH, San Francisco CA

Printed in the United States of America

Library of Congress Catalog Card Number: 2007937384

For all general information contact Arcadia Publishing at:
Telephone 843-853-2070
Fax 843-853-0044
E-mail sales@arcadiapublishing.com
For customer service and orders:
Toll-Free 1-888-313-2665

Visit us on the Internet at www.arcadiapublishing.com

This book is dedicated to all those who have volunteered their time
and talents to the Summit Historical Society and
the Frisco Historical Society over the years.

CONTENTS

Acknowledgments 6

Introduction 7

1. The Utes, the Original Inhabitants 9

2. Mining the Precious Minerals 13

3. Mining Towns and Camps 37

4. Lifestyles in the Victorian Era 73

5. Transportation, Overcoming Isolation 93

6. Agriculture along the Lower Blue River 111

7. Recreation, Fun, and Relaxation 119

Epilogue 125

Bibliography 126

Index 127

Acknowledgments

The author wishes to thank a number of people who helped make this book possible: Charles Bond, David Spencer, and Maureen Nicholls from the Summit Historical Society; and Simone Belz from the Frisco Historical Society. Images in this book are from the Summit Historical Society archives, the Frisco Historical Society archives, and the private collections of Robert L. Brown, Raymond Ritchey, and the author.

INTRODUCTION

Colors and contrasts: that is how authors have remembered Summit County, Colorado, over the last 150 years. One described the blue of the sky, the white of the clouds, the gray of the sagebrush, the green of the meadows, and the yellow of the aspens in fall. Another recalled the clustered buildings under the vast blue sky, tiny wildflowers next to huge dredge piles, steep mountainsides adjacent to flat valley bottoms, and strong winter winds giving way to gentle summer breezes.

The Blue River—with its major tributaries, the Snake and Swan, which enter from the east, and the Ten Mile, which enters from the west—drains the county. The Blue has its source near Hoosier Pass and flows north to join the Colorado River near Kremmling in Grand County.

The human story begins with the Utes, whose ancestors had lived in the valley of the Blue River for generations. An early explorer traveling in the area remembered "buffalo and wild flowering glens." Another wrote in his journal that the expedition camped in the shade of pines in an area that was "alive with buffalo." With the arrival of the gold-seekers in 1859, the hunting-gathering lifestyle of the Utes disappeared in the space of a few years.

Mountain men enjoying a rich harvest of furs for European markets spent many winters in what is now Summit County. Each fall they gathered at pre-designated rendezvous spots to trade their furs for the goods needed to survive the winter. One such spot near old Dillon, at the confluence of the Blue and Snake Rivers and Ten Mile Creek, was called LaBonte's Hole. While they left few marks on the landscape, the mountain men opened the West for the ranchers, merchants, and miners. They knew of the mineral wealth but chose to remain silent to preserve the animal habitats so vital to their livelihood.

Mining towns and camps quickly sprang to life, and hundreds of men from all walks of life joined the frantic search for instant wealth. Merchants followed the miners in rapid succession, mining the miners, perhaps grub-staking those who needed financial support, and happily pocketing some of the profits. At first, the merchants supplied only the basic necessities. Stores sold mining supplies, food, clothing, and, in some cases, liquid refreshment. Saloons offering drinks, games of chance, and companionship became an integral part of most mining towns. Buildings were hastily constructed with little thought for longevity. It was only later that stores offering "niceties" like stationery, Valentines, candies, and jewelry appeared along the street.

The independent prospector of the 1860s evolved into the company man of the 1880s. Saloons advertised themselves as "resorts for gentlemen." Tastefully decorated rooms were available for conducting business and entertaining investors.

With the coming of the railroad in 1882, mining prospered as it had not done before. Stores sold fresh fruit and vegetables brought by the railroads. Women and families arrived. Churches, schools, and fraternal organizations appeared on the landscape. For those who could afford the finer things, trains brought French wines, perfumes, lace, and even pearl-encrusted calling card cases. For others, catalogues and traveling salesmen, arriving by train, offered goods and services.

A variety of languages was spoken by those coming to the county. Immigrants came from Germany, Canada, England, Scotland, Wales, Cornwall, Ireland, France, Denmark, Austria,

Sweden, Switzerland, Norway, China, and, of course, the eastern United States. Pennsylvania, New York, Ohio, and later Illinois were "home" to the majority of those arriving in the county before 1880.

Miners used a variety of mining techniques to extract the gold and other minerals for which Summit County is famous. Each method took its toll on the environment. The first miners to arrive tried panning in the streams and gulches. Hoping to extract more gold, the miners turned to hydraulic methods using hoses called "giants" or "monitors." Hardrock miners tunneled deep below the surface looking for rich veins of minerals. In 1898, the first of nine dredges literally turned the riverbeds upside down searching for gold. Companies financed by investors in the eastern United States and England faced many problems turning their quest for a profit into reality.

While mining dominated the economy in the southern part of the county, ranching and agricultural pursuits were found in the northern section. Cattle, horses, and sheep were raised for markets in the East. Ranchers quickly discovered which crops could survive and mature in the cold, snowy winters and short, dry summers.

Summit County has offered a wide variety of resources through the decades. Those that were of prime importance at any one particular moment gain or lose importance over time because of changing technology and attitudes. To the Utes, it was the buffalo; to the mountain men, it was fur-bearing animals. To the miners, it was, at first, gold. But with the improving techniques to extract silver, lead, and zinc, these resources took on major importance. Today the beaver, buffalo, and minerals are generally of little value. Rather the climate with its heavy snow that supports winter skiing and the dry summers offering relief from the heat of the Plains and humidity of the East Coast is of prime importance.

The landscape of Summit County is dynamic. It evolves through time. The Ute landscape was based on a hunting and gathering economy. It was overlain by the mining and ranching landscapes that generally developed at opposite ends of the county. Today these relict landscapes are being covered with features of the summer and winter recreational landscapes. As the successive tiers form, the past shows through. Ute trails and passes—subsequently used by miners, ranchers, merchants, and railroads—are now used by a myriad of motorized vehicles. Mining buildings, many in poor condition, and abandoned equipment dot the mountainsides. Pastures, fences, and farm buildings tell of the agricultural landscape.

Visitors who come in both summer and winter to enjoy Summit County's recreational opportunities can still see and experience the life of those who lived in the late 1800s and early 1900s by visiting museums, mines, and historic houses from that time still found throughout the county.

One

THE UTES, THE ORIGINAL INHABITANTS

For centuries the land that would become Summit County provided the necessities of life for humans. As long as 12,000 years ago, hunters roamed the area in search of food. Charcoal from campfires, projectile points, knives, and scrapers tell of the continuous occupation of specific sites. These people were the ancestors of the White River Utes found by trappers, travelers, miners, merchants, and others coming to Summit County. Because of the isolation provided by the mountainous terrain and deep valleys, the bands of Utes in Summit County were quite distinct from those living in Utah. Those in Summit County had adopted many cultural traits of the Plains Indians, who were at various times their rivals, allies, or enemies.

The Ute way of life left distinct marks on the landscape as the bands followed the buffalo between summer grazing lands along the Blue River and winter quarters at lower elevations. The passes used by the Utes became the early wagon roads. Present-day highways follow some of these same routes.

The biggest legacy of the Ute occupation came from their use of fire. Yearly the Utes burned the valley bottoms to encourage the short, tender grasses that the buffalo and horses preferred. Besides improving pasturage, the fires facilitated travel, removed unwanted trees, and improved visibility. The fires destroyed species that could not tolerate repeated fires and encouraged the growth of lodgepole pines, whose cones can open only after being subjected to heat. The buffalo further changed the vegetative character of the county. Large herds stripped the ground of most of the grasses. Anything not eaten was trampled. Therefore much of the vegetative landscape in place when the miners and others arrived was a direct result of the Ute lifestyle.

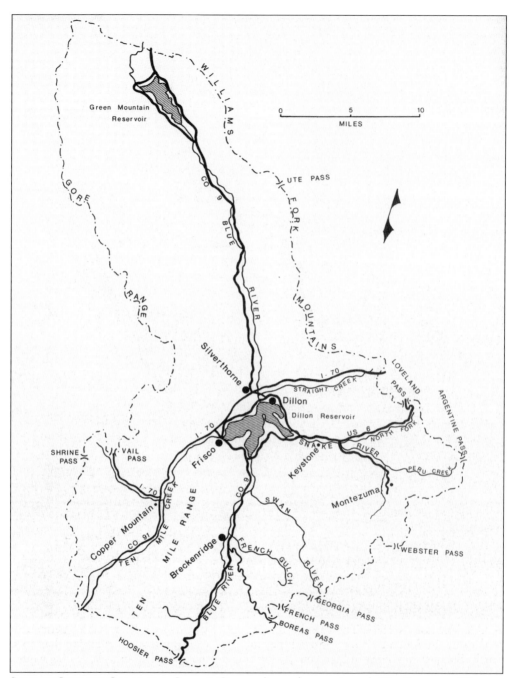

SUMMIT COUNTY, COLORADO. Summit County, located approximately 75 miles west of Denver, is home to 60 mountain peaks over 11,000 feet, four ski resorts, two reservoirs, and numerous high-altitude mountain passes. Dillon and Frisco are located on Lake Dillon, while Breckenridge lies to the south along the Blue River. Montezuma overlooks the Snake River in the eastern part of the county.

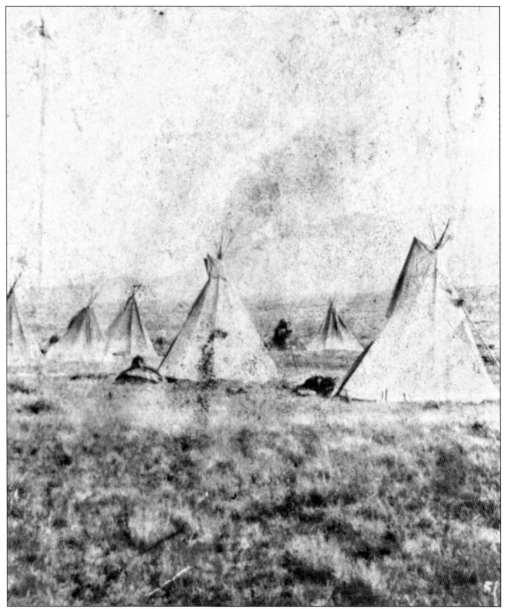

A UTE VILLAGE IN 1899. The Utes lived in groups of various sizes. They had no permanent settlements in Summit County. Instead they migrated with the seasons, following their food supply. Summer was spent in high country hunting buffalo and other animals. During winter, they foraged in low country, especially in protected valleys where streams provided fish and small game. Women gathered herbs, berries, and roots to enhance their diet.

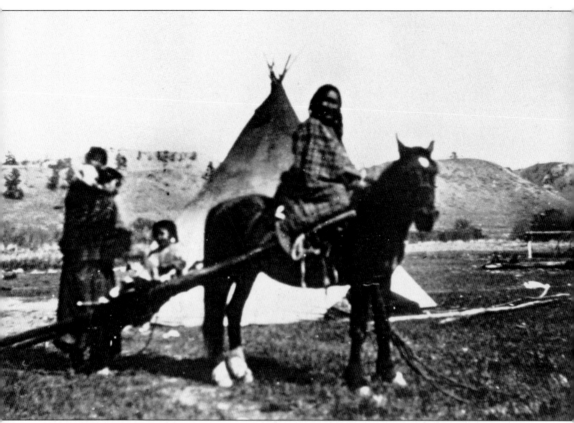

HORSE WITH TRAVOIS. Shelters reflected the Utes' hunting-gathering lifestyle. Summer homes, called wickiups, were made of brush and willow arranged over a wooden frame. Winter homes were the tepees of the Plains Indians built with the lodgepole pines so abundant in the county. Their dress was that of the Plains Indians. The horse-pulled travois, holding as much as 100 pounds, made life easier for the women.

Two

MINING THE
PRECIOUS MINERALS

If it had not been for the glaciers that filled the alpine valleys, the history of Summit County would have been quite different. Glaciers and running water eroded gold-bearing rocks and carried the gold into streams and rivers where it settled to the bottom of the waterways. To reach the placer (pronounced pla-suhr) gold and, later, the mother lodes themselves, miners employed varying methods, all of them leaving an imprint on the land. The impact depended on the type of mining and the amount of technology applied to the search for the precious mineral.

A simple philosophy reigned supreme: mining first—natural beauty second. In 1916, the editor of the *Summit County Journal* wrote about the "wonderful transformation wrought by man" in the county. He praised the miners, saying that before they arrived to change the "face of nature," there were no "great white and brown dumps, no fuming smoke stacks and no rumbling mills."

Even in the best of times, mining was difficult in Summit County. Money for development was rarely abundant. Companies continually looked for investors to bankroll their operations. Isolation and inadequate transportation facilities strangled development. Much of the ore was low grade and expensive to ship to concentrators and smelters. Extracting the gold from ore found at depth proved extremely difficult. The methods used could not recover enough of the gold to be profitable.

A significant amount of the mineral wealth of Summit County remains today. However, the process for establishing a mining operation is long and arduous, and the ore bodies are not rich enough to be profitable. The environmental damage would be far too great in an area now drawing summer and winter visitors because of its natural beauty.

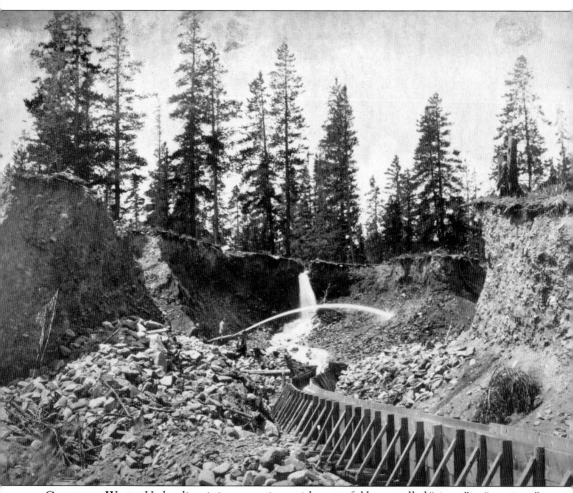

GIANTS AT WORK. Hydraulic mining operations with powerful hoses called "giants" or "monitors" caused great damage to the environment. Fed by diverted steams, the hoses washed the loosened gravel into long sluice boxes. A giant could swivel 360 degrees, as well as move up and down. Tremendous water pressure was maintained. A runaway giant or exploding monitor could easily kill the giant operator or others in the area.

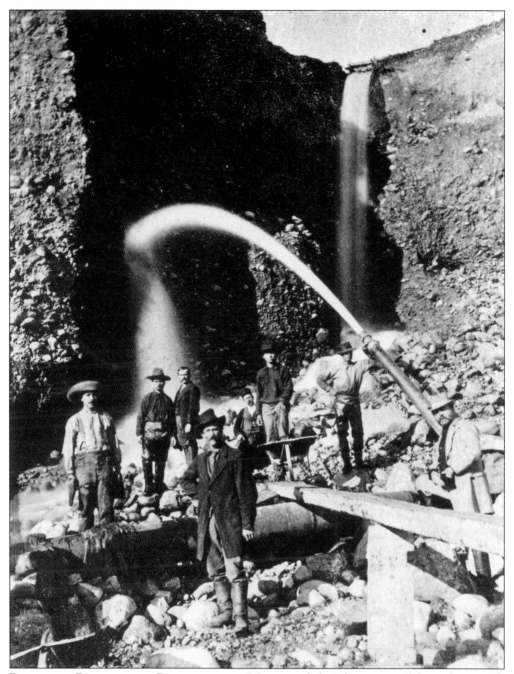

PITTSBURG PLACER NEAR BRECKENRIDGE. Miners and their bosses posed for a photograph amid placering operations. Water diverted upstream entered the pit and ran in a torrent to pipes feeding the "giant" or "monitor." As the water washed the unconsolidated gravel from the pit walls, it re-entered the stream of water that fed the giant. Unseen sluices extracted the gold from the gravel washed from the pit walls.

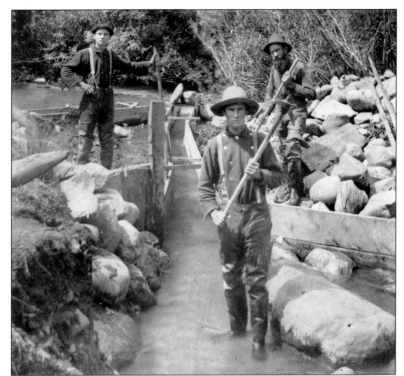

SLUICING. Miners built wooden sluices lined with burlap or cocoa matting to catch the gold. They nailed wooden strips called riffles several inches apart to hold the burlap in place. Mercury, which can hold 50 percent of its weight in gold, was laid on the upslope side of the riffles. At clean-up time, the burlap was burned, the mercury vaporized, and the gold collected.

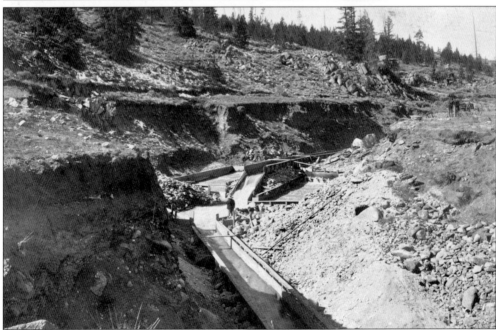

UNDERCURRENT SLUICES. Too much water created just as much of a problem for sluicing operations as too little. To control the speed of the water, miners constructed undercurrent sluices beside the main sluice, as seen in the center of this photograph. Water was diverted to the sluices that were equipped with riffles and copper sheeting impregnated with gold and mercury. The water exited via other sluices.

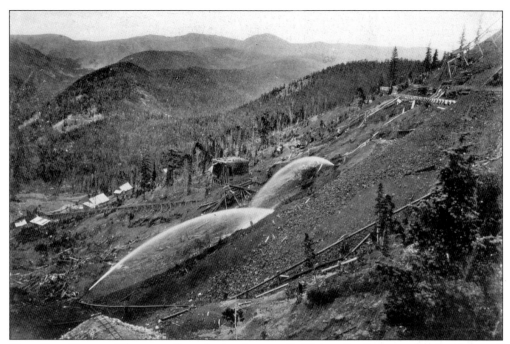

GOLD RUN PLACER. The power from the iron hoses called "giants" or "monitors" stripped the soil and vegetation, exposing bare rocks. The water feeding the hoses was brought from far upstream and fed into pipes. As the diameter of the pipes decreased, the water pressure increased until the tremendous pressure needed to attack the hillsides was created.

HYDRAULIC OPERATIONS. Many miles of water ditches were necessary to collect the tremendous volumes of water needed for hydraulic operations. Companies bragged about the miles of ditches they built. Keeping water in those ditches was a challenge. In an attempt to prevent leakage, some of the ditches were lined with a mixture of sawdust and manure, two things found in abundance in Summit County.

GOLD RUN DITCH ON FORD HILL. Ditches such as this one supplied water to the hydraulic operations around Breckenridge. Water from the Blue River fed this 8-mile-long ditch. Each fall when the water was cut off, people came to the ditch to claim any fish left as the ditch emptied.

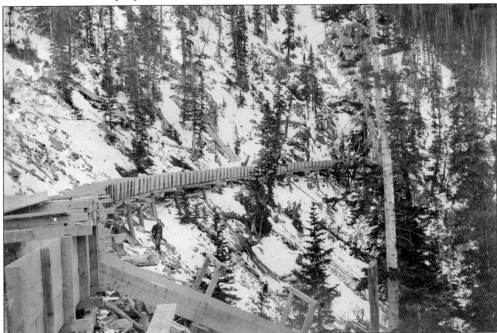

THE GREAT FLUME. This flume fed hydraulic operations in the American and Georgia Gulches. Consisting of five segments, made up of three flumes and two ditches, the flume stretched 33 miles. The longest segment extended 14 miles from the Middle Swan River near Swandyke to Georgia Gulch. Construction started on this segment in 1872 and continued until 1874. The waste gate in the foreground diverted water if repairs were needed downstream.

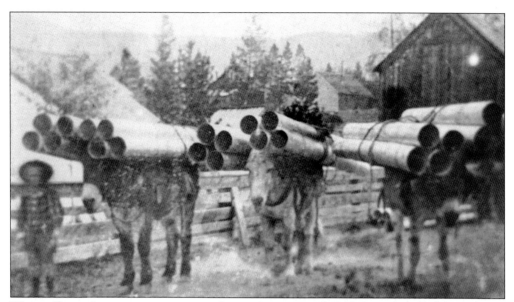

WATER PIPES. Later, to prevent ground seepage as water flowed through a ditch, wooden or metal pipes were laid in the ditches. The railroads brought the finished pipes or the metal plate to fashion the pipes. Jack trains carried the finished pipes to the ditches.

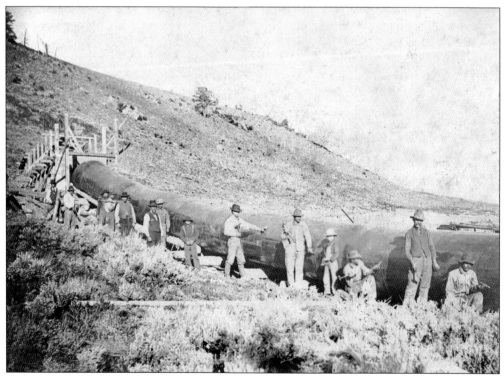

INSTALLING A WATER PIPE. Men, under the watchful eye of company executives, put the finishing touches on sections of a large-diameter water pipe. Water carried by the wooden flume will enter the pipe and be carried to hydraulic operations down slope. Note the wooden bracing on the flume. A "giant" or "monitor" lies beyond the water pipe on the right.

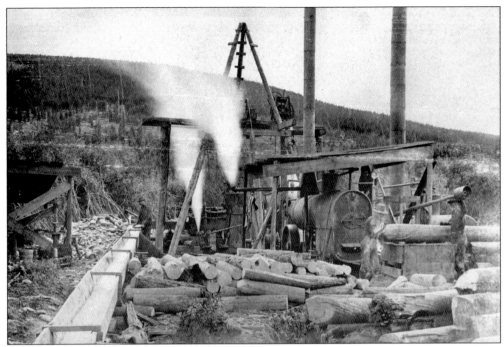

SAWMILL. Sawn lumber was needed for homes and buildings, mine tunnels, water pipes, sluice boxes, railroad ties, water ditch gates, and ore wagons. One- and two-person sawmills sprouted as abundantly as the wildflowers. Of course, there was always time to do a bit of gold panning when the day's work was done.

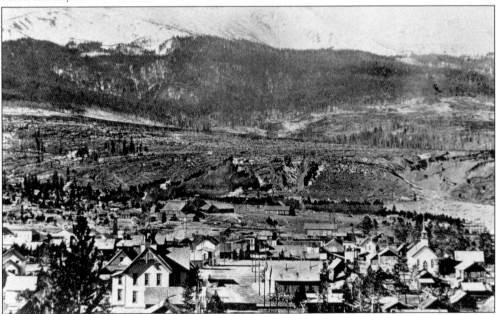

ENVIRONMENTAL DAMAGE. Placering operations on the hills west of Breckenridge washed tons of mud and rocks into town, creating a debris fan north of the Ware-Carpenter Concentrating Mill. By the mid-1890s, the hillsides were stripped of trees to feed the lumber mills found throughout the area. In the left foreground is the 1882 school; to the right is Father Dyer Methodist Church.

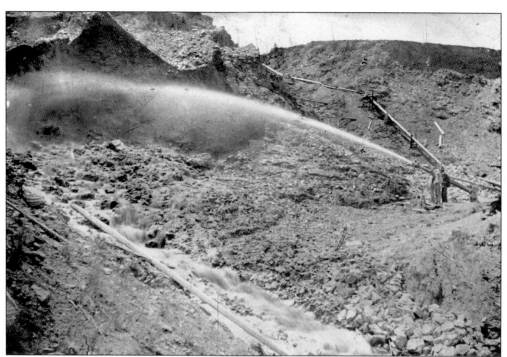

MINING IN GOLD RUN GULCH. In 1884, the editor of the *Breckenridge Daily Journal* wrote that the mineral veins of Summit County would furnish employment for centuries. The miners would wash away the boulders, gravel, and soil, exposing the veins. The area would be uninhabitable, but that was "okay" because Summit County would provide the world with an endless supply of mineral wealth.

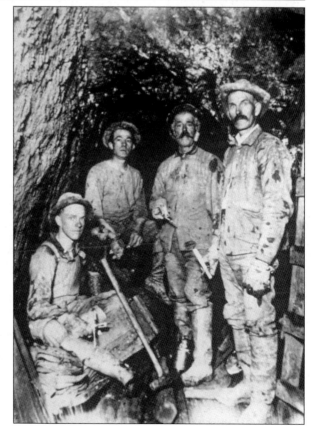

WALKING TO WORK. With their candles, these men are ready to begin work after descending the ladder in the man-way. Miners called this "walking to work." Three candles lasted through a 10-hour shift. Sometimes mines supplied the candles; otherwise miners bought their own. Candles were held in place on the brim of a hat by a lump of clay or placed in a candle holder wedged into a timber.

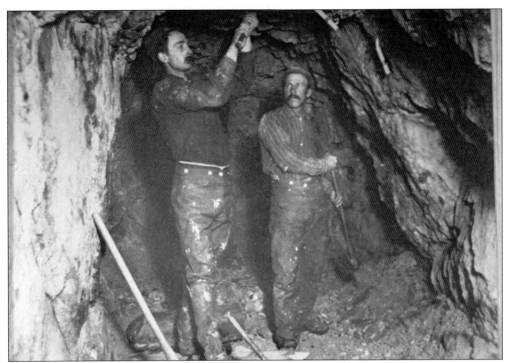

PREPARED FOR WORK. With candles and eight-pound sledges, these men are prepared for work. For safety's sake, miners preferred to descend using a ladder rather than riding the bucket. The candles, placed in forged iron holders, will be wedged between rocks and timbers. Boots keep their feet dry while their resin-hardened hats provide a bit of protection from falling rocks.

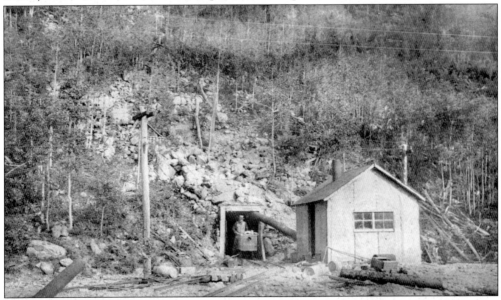

TRAMMER IN PORTAL OF ADIT. In this photograph taken between 1906 and 1909, a trammer pushing an ore car emerges from the portal of the Mary Verna Mine in the Ten Mile Canyon. Next to the track rests a timber cart that could be lifted onto the tracks and pushed into the adit. The pipe carried compressed air into the mine for use by pneumatic drills.

WINDLASS. Miners used a hand-powered windlass in shafts less than 75 feet in depth. The shaft collar was timbered for stability and for the safety of those who worked around the collar. The bucket, raised and lowered by the cable, carried ore, drill steels, and other mining equipment. Sometimes men rode the bucket up and down the shaft.

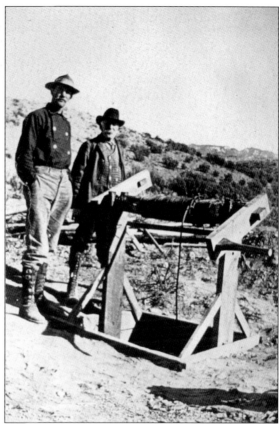

HILLTOP CONSTRUCTION. Many mine buildings were located on the narrowest of ledges, perpendicular to the slope. This hastily constructed vertical plank building with an uneven roofline is a good example. The slope made dumping ore cars much easier. Note the track beneath the ore cart.

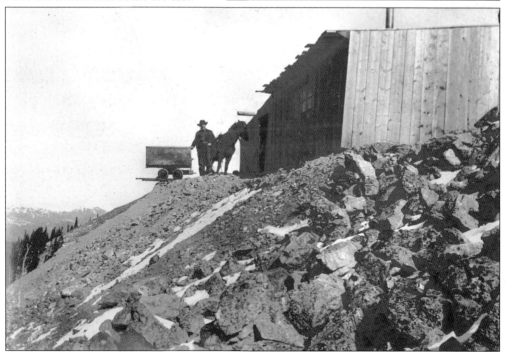

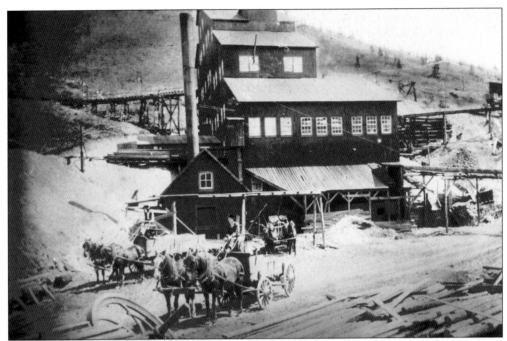

THE WELLINGTON MILL. This mine in French Gulch, which opened in 1887, continued operating until 1973. Veins produced lead, zinc, gold, and silver. Ore entered the mill on the trestle seen in the background. Processed ore left the mill on the lowest level. Each step of the ore-processing operation depended on gravity to take the ore from one level to the next.

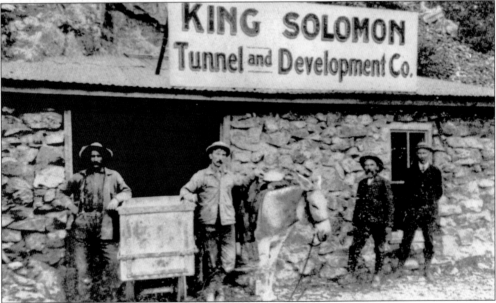

KING SOLOMON MINE. Located on the east side of the Ten Mile Canyon, the King Solomon Mine produced silver, iron, and lead as late as 1910. Financed by the King Solomon Mining Syndicate, it was managed by James H. ("Dimp") Myers Jr. His father, Col. James H. Myers Sr., was the head of the syndicate. Track for ore carts pulled by burros lined the 3,000-foot-long tunnel dug into Mount Victoria.

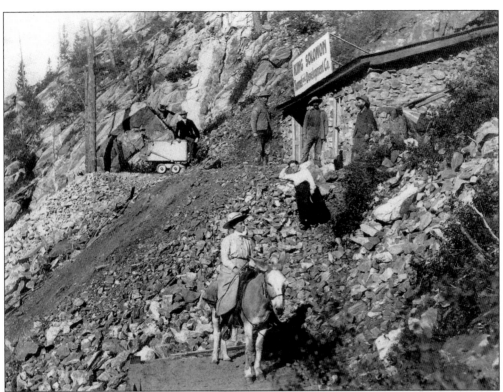

VISITORS TO THE KING SOLOMON MINE. Miners tended to be quite superstitious. Whistling was prohibited in a mine, and an inverted horseshoe over the entrance brought good luck and rich ore. Women usually were not permitted inside a mine because that would surely bring bad luck. These women might not be allowed any closer than the portal of the adit.

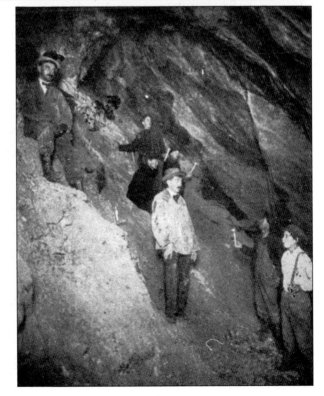

THE CHAUTAUQUA MINE IN 1907. Mine executives carrying miners' candles pose for a photographer while inspecting the mine. The young boy to the right might be a breaker boy hired to sort the rock removed from this mine near Montezuma.

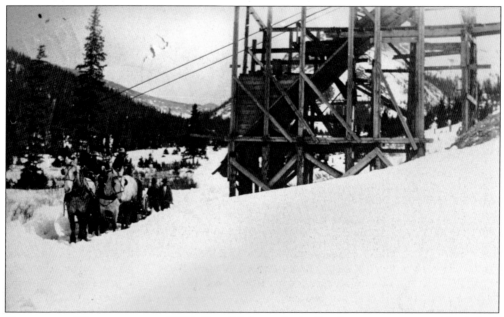

TIPPLE NEAR MONTEZUMA IN 1909. Ore slid down the incline into ore wagons waiting below, which would take the ore to a nearby mill or railroad depot. Cables from a tram used to carry ore up the slope, and possibly to the top of the tipple, are seen just beyond the tipple. During winter months, sleds transported the ore.

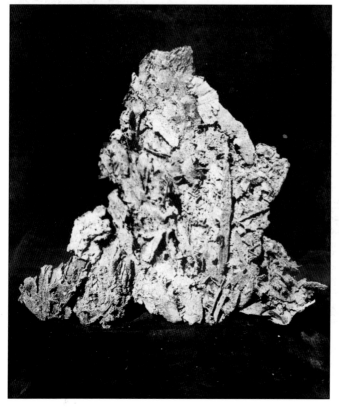

TOM'S BABY. On July 23, 1887, Tom Groves and Harry Lytton, who were leasing part of the Gold Flake Mine on Farncomb Hill, discovered this mass of crystalline gold weighing 13 pounds and 7 ounces. "Tom's Baby" disappeared for many years before its rediscovery in 1971 in the United Bank of Denver. It is now on display at the Denver Museum of Nature and Science.

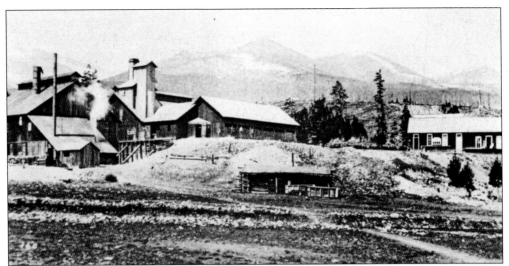

WARE-CARPENTER CONCENTRATING MILL IN BRECKENRIDGE. Mills were either custom or integrated mills. Custom mills processed ore from mines that could not afford their own mills. Integrated mills handled ore from a group of mines owned by the same company. Col. Mason B. Carpenter and Col. Alfred J. Ware owned the mine where Tom Groves and Harry Lytton found "Tom's Baby" in 1887.

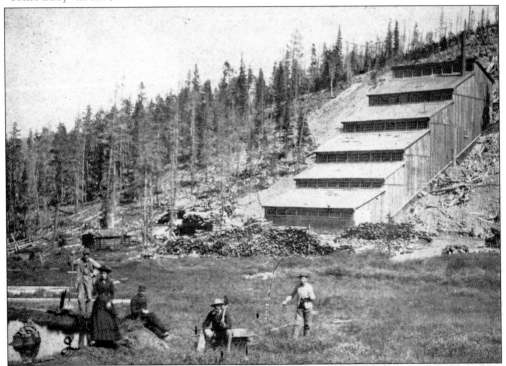

BROOKS-SNIDER MILL. Mills were built on a hillside to take advantage of gravity in the milling process. Unprocessed ore brought from nearby mines entered the mill at the highest level. Men and machines worked together to pulverize the ore, discard the unused portion, and prepare the concentrate for smelting. On the lowest level, the processed ore would be loaded on wagons for the trip to a smelter.

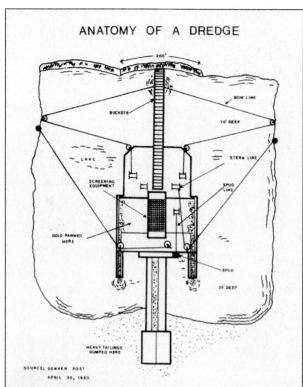

ANATOMY OF A DREDGE

ANATOMY OF A DREDGE. A dredge floated in a pond of its own creation. Cables anchored the dredge to the shore. A hollow spud pole with walls 4 to 6 inches thick anchored the boat to the floor of the pond. Inside the dredge, screening equipment and sluices caught the gold. Waste exited via the stacker at the rear of the dredge.

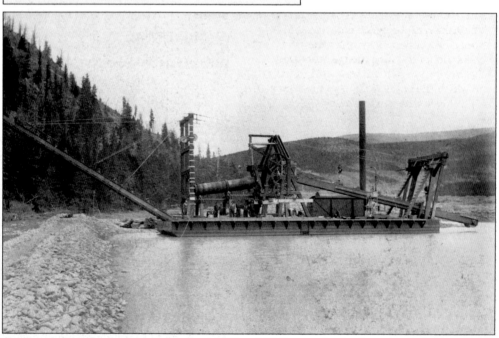

AN EARLY DREDGE AT WORK. Between 1898 and 1942, nine dredge boats worked the gravel in the valleys of the Swan and Blue Rivers and French Gulch where the stream gradient was gentle, the workable gravel deep, and the supply of water sufficient for year-round operations. An endless chain of buckets dug to bedrock searching for the gold.

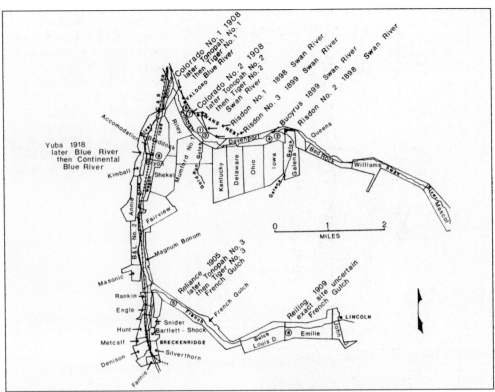

THE DREDGE BOATS OF SUMMIT COUNTY. The names, approximate construction sites, construction dates, and areas of operation for the nine dredge boats are shown along with the names of the placers on which the boats dredged in the Blue and Swan River Valleys and French Gulch.

BUCKET LINE. The bucket line on a large dredge dug as much as 70 feet into the stream bed. In this undated photograph, the buckets excavate gravel in the Swan Valley. These electric-powered dredges had over 80 buckets, each holding 8 cubic yards of gravel. Note the size of the men standing on the bank in front of the dredge compared to the dredge itself.

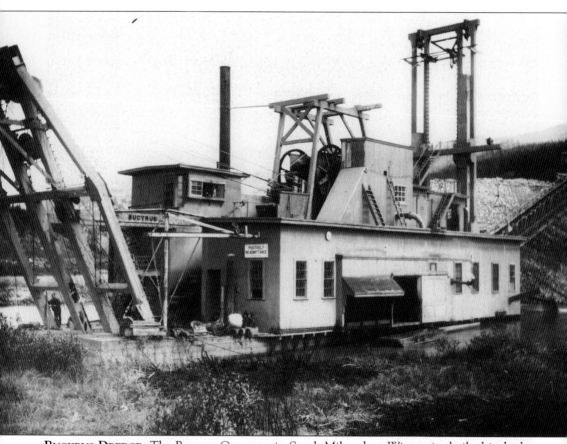

Bucyrus Dredge. The Bucyrus Company in South Milwaukee, Wisconsin, built this dredge in 1908. Powered by electricity, the dredge could process more than 3,000 cubic yards of gravel in 24 hours. The bucket chain excavated to depths of over 50 feet. Each bucket held 9 cubic feet of gravel. This dredge worked the gravel in both the Swan and Blue Rivers.

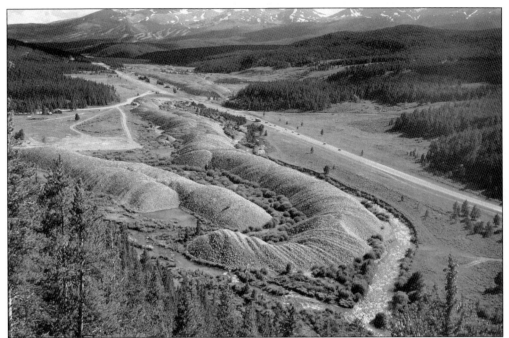

DREDGE PILES. After the dredges finished working the river valleys, piles of rock filled the waterways. Finer material at the base of the piles could support vegetation, but the rock piles themselves were barren. In this photograph, the Blue and Swan Rivers continue to flow around the rock piles.

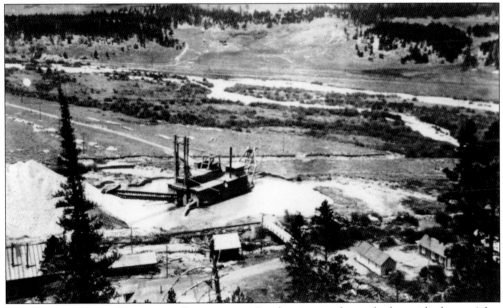

BEFORE AND AFTER DREDGING OPERATIONS. Dredging turned river beds upside down. After a dredge worked the river, the gravel rested in huge piles, never to return to its original position. Much of the finer material that had supported plant life washed downstream. Aquatic life found it impossible to survive. This Bucyrus dredge is working in the Swan River. The undisturbed Blue River is in the background.

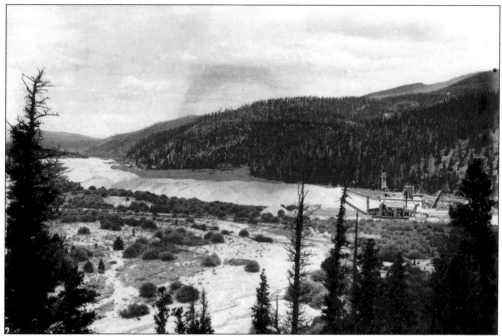

Passing Dredges. Multiple dredges worked the river valleys. Here a Bucyrus dredge is passing an abandoned Risdon dredge on the Swan River in 1909. The piles of rock created by dredging operations surround the boats. Dredges often retraced their paths and the paths of other dredges looking for that last ounce of gold.

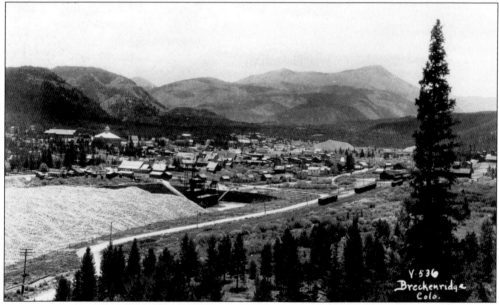

Tonopah Dredge Entering Breckenridge. When the Tonopah Company requested permission to dredge through town, the town board refused. Under pressure from the mayor, who was also the superintendent of the dredge, the board reversed its decision. A few years later, the mayor, who had been standing on the edge of the pond, fell in and drowned. The newspaper editor, opposed to dredging in town, wrote, "Just retribution."

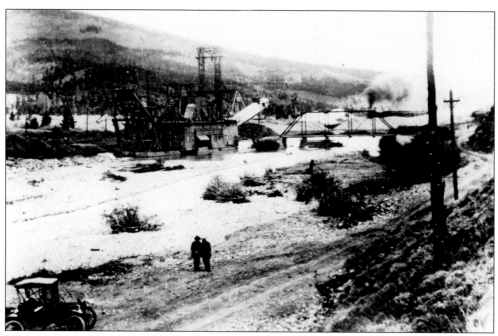

DREDGE BOAT OPPOSITION. Opponents to dredging operations were formidable and vocal. Opponents cited such things as the health factor (because the Blue River contained raw sewage), ruined property, ruined property values, unstable sides to dredge ponds, and noise pollution. Operations ceased because of the inability to reach bedrock, bankruptcy, legal proceedings, and popular opposition.

THE GOLD PAN SHOPS. Although the Gold Pan Shops on Ridge Street in Breckenridge fabricated all sorts of machinery needed by the railroads and mines, their principal product became water pipes for hydraulic mining. Boiler plate for the pipes arrived on the railroad. Each pipe weighed between six and seven tons, with some reaching 40 feet in length. The pipes were dipped in tar-filled vats to prevent corrosion.

33

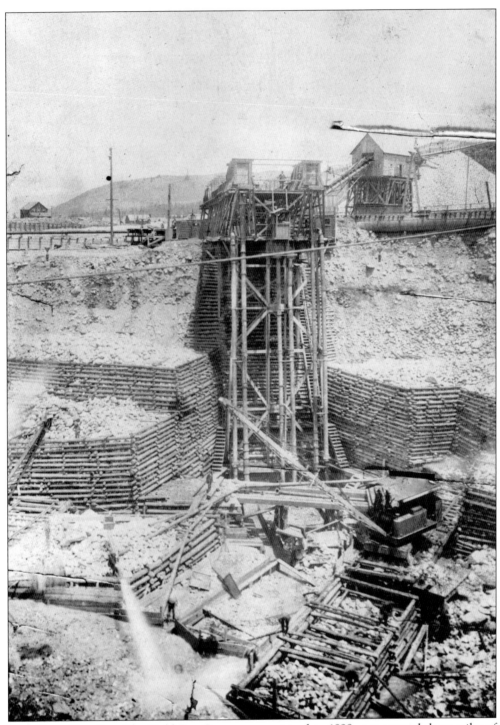

THE GOLD PAN PIT. The Gold Pan Company, organized in 1899, constructed three miles of ditches to bring water to its 73-foot-deep pit operation. Six "giants" washed the gravel into hydraulic elevators that carried it to sluices on the surface. When the pit operation proved unsuccessful, the water was used to provide electricity for streetlights in Breckenridge beginning in August 1901.

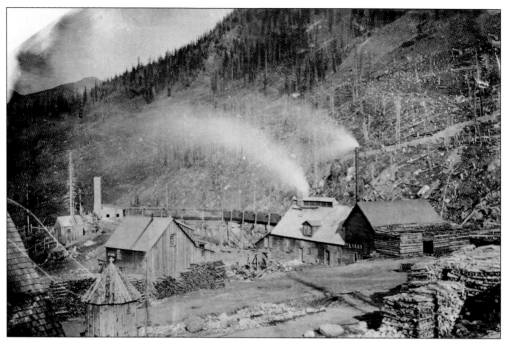

STS. JOHN SMELTER IN 1898. English money financed the mining and milling operations in Sts. John, near Montezuma. The smelter processed ore from the surrounding mines. Trees on nearby hillsides provided the vast amount of lumber needed for the smelting process. Bricks for the smelter arrived from England. The conical building in the foreground housed a well.

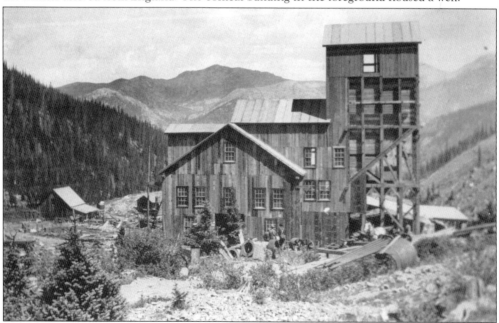

MILL AT STS. JOHN. The mill was one of many buildings found in the town of Sts. John, named for the patron saints of freemasonry, St. John the Baptist and St. John the Evangelist. Near the mill were miners' homes, a company store, a post office, an assay office, a dining hall, a library, a boardinghouse, and a smelter—but no saloons.

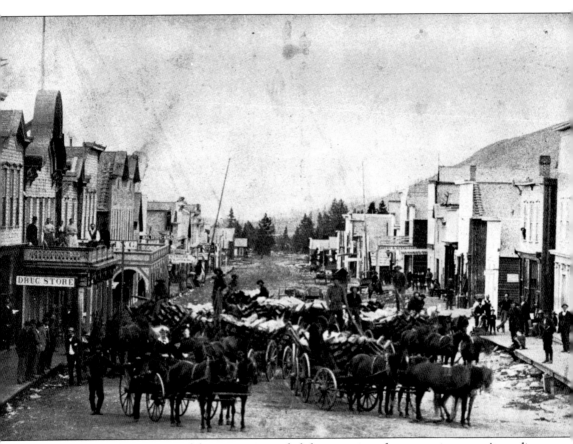

ORE TRAIN. An ore train of this size commanded the attention of everyone in town. According to the *Summit County Journal*, $7,021,000 worth of placer gold was produced in Summit County from 1859 until 1884. By 1922, the estimate reached $20 million. The nine dredges in the county were thought to have recovered $21 million from the streams and rivers. The total estimated mineral production for 1859 to 1922 was worth $71,350,000.

Three

MINING TOWNS AND CAMPS

Many early mining camps and towns blossomed with little planning or organization. Miners and merchants selected a site in the middle of a forest or on a hillside. They placed tents and crude log cabins haphazardly on or near claims. A main street—nothing more than a pathway through stumps, boulders, and shallow streams, and lined with tents and structures sporting false fronts—soon took shape. Other towns appeared when a land speculator laid out a site with numerous wide streets. Blocks of building lots for thousands of people were surveyed and offered for sale. There were a number of such schemes in the county. Some succeeded; some did not.

The layout of towns such as Breckenridge followed a typical pattern. The main street followed the stream on one side while the railroad was built on the other. Next to the tracks were mills, concentrators, a railroad depot, sawmills, and a red-light district. General stores, liveries, hotels, boardinghouses, and other businesses lined the major street, often mixed with residences. Wealthier families lived on streets of higher elevation overlooking the rest of the town. In Breckenridge, these were east of the river.

Regardless of the topography, the grid pattern was the most popular street plan in Summit County. Because it was easy to draw rectangles on a map, it was the easy choice for the person who laid out the town. Its regularity reduced the number of surveying errors while providing a variety of lot arrangements within a single block.

The towns of the mining era differ from those of today in an important way. In their earliest stages, mining towns suffered from a complete lack of amenities. Today it is the amenities that draw visitors to the county. A big challenge is finding a balance between preserving some of the landscape resulting from the mining era amid the recreational landscape now in place.

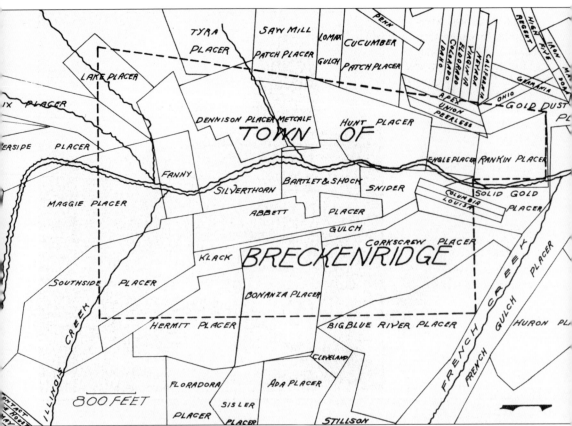

TOWN OF BRECKENRIDGE. The original 320-acre town site straddled the Blue River on this February 23, 1879, map. The town was platted directly over existing placers. The map includes placers within and adjoining the town of Breckenridge. By this time, there had been much consolidation of the placers existing in 1860.

BRECKENRIDGE, MID-1860S. Breckenridge sprang to life the year after gold was discovered in the Blue River, north of where the town is now located. The town site was platted by a prospecting company led by Gen. George E. Spencer, who became a U.S. senator from Alabama during the Reconstruction period, and others. Notice how the town developed directly over the placer diggings, claims, and ditches.

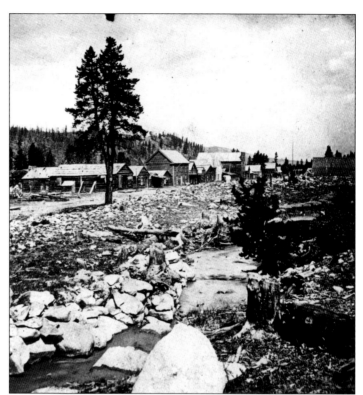

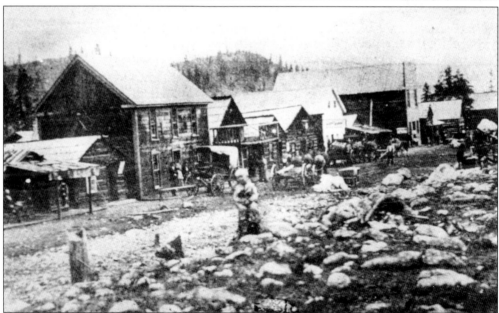

MAIN STREET, MID-1860S. In 1866, Bayard Taylor wrote that Breckenridge consisted of covered wagons in the shade, a long street of log houses, signs advertising boardinghouses and saloons, and a motley group of rough individuals. Accommodations in the boardinghouses were primitive, offering little in the way of privacy. William Brewer, in 1869, described Breckenridge as having a single street of one-story cabins covered with dirt rather than shingles.

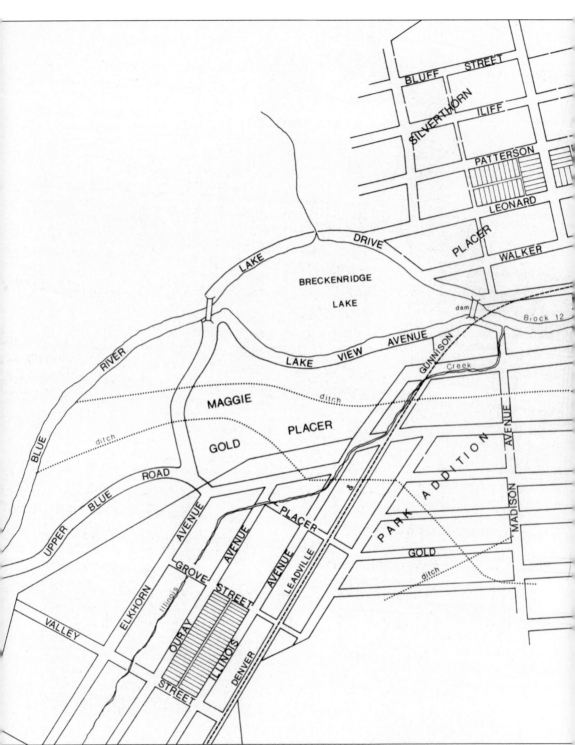

MAP OF BRECKENRIDGE. Drawn as an advertising piece, the *c.* 1900 map listed town and county officers, and an abbreviated business directory. The map shows that town streets featured a grid pattern with residential and business lots for hundreds of residents. The railroad paralleled the

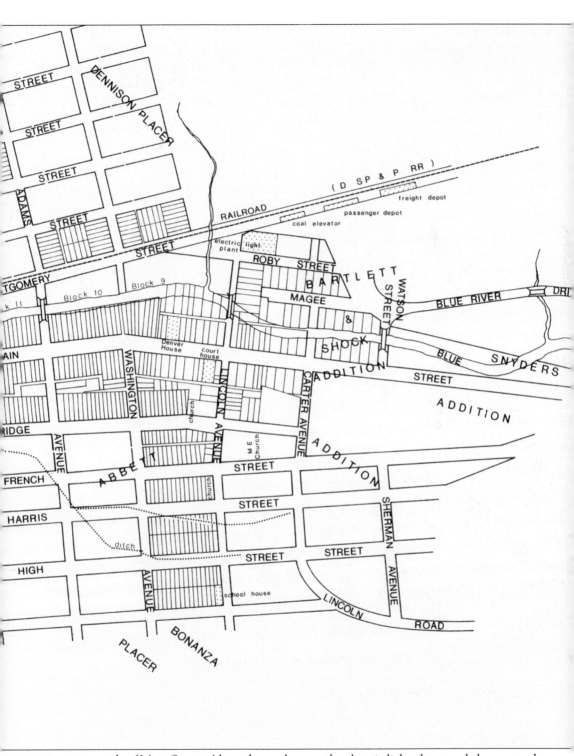

river to one side of Main Street. Along the tracks were the electric light plant, coal elevator, and railroad depot.

BRECKENRIDGE IN 1898. The etching is based on a photograph taken from Barney Ford Hill. To the west of the Blue River is the railroad. Visible are bare hills and gulches created by placering operations. The 100 block of South Main Street is crowded with buildings while the 200 block is relatively empty because of a fire that swept both sides of that block in May 1896.

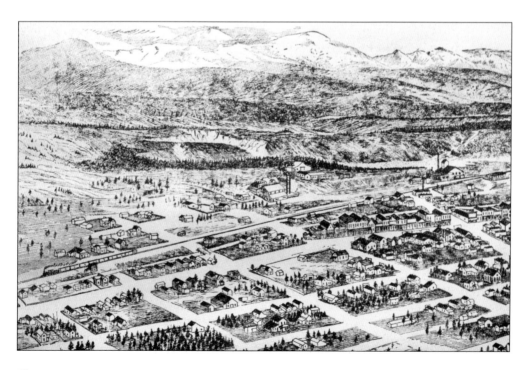

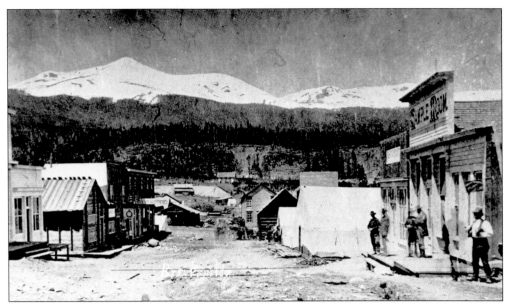

LINCOLN AVENUE IN 1880 OR 1881. Tents, one-story log structures, and sawn-lumber buildings, many with false fronts, lined the street. To the left on the south side of the street are a drugstore and jeweler. On the right is the Sample Room. The streets commissioner had a difficult time keeping the roadway free of large boulders. Note the fire ladder on the one-story building to the left.

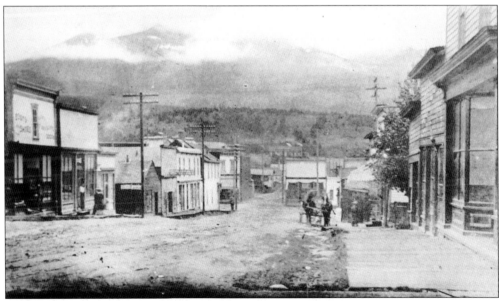

LOOKING WEST ON LINCOLN AVENUE TOWARD MAIN STREET. In this undated photograph showing the major intersection of Breckenridge, the saloon on the northwest corner of the intersection is seen directly behind the two horses. The man standing next to the electric light pole is beside the saloon on the southeast corner of the intersection. A general store occupied the southwest corner and a blacksmith shop on the northeast corner.

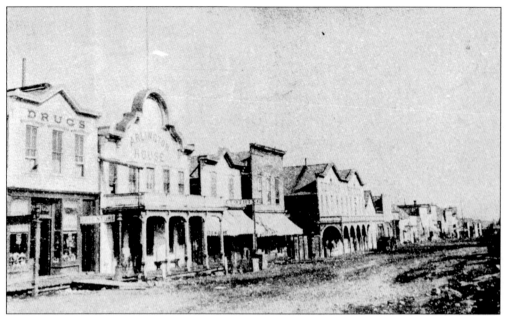

ROOFLINES OF PROSPEROUS BUSINESSES IN BRECKENRIDGE. The ornate rooflines on the businesses on the western side of Main Street show the town's prosperity in the mid-1880s. Wooden sidewalks kept feet and long dresses out of the mud in spring and snow in winter. The false fronts on the buildings gave a sense of permanence to Turk's Drug Store, the Arlington House, and the Denver Hotel.

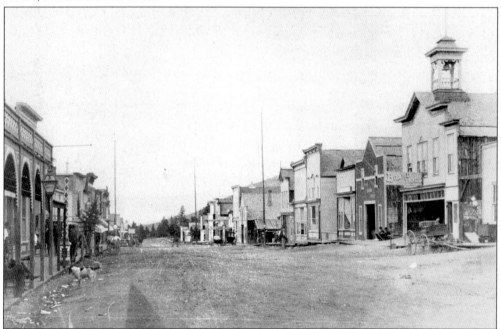

WIDE MAIN STREET. Mining towns such as Breckenridge generally had wide streets to turn the large ore and supply wagons that passed through town. But there was another reason: fire. It was hoped that flames on one side of the street would not ignite buildings on the opposite side. In this undated photograph, the fire hall is seen on the extreme right behind the wagon.

44

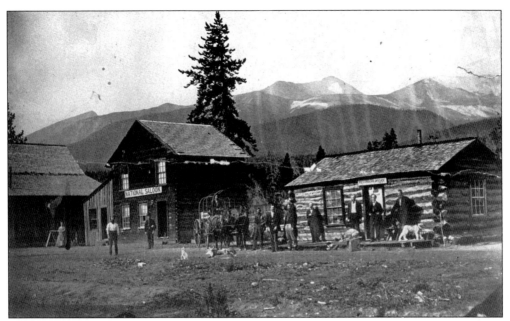

THE NATIONAL SALOON. The National Saloon on Main Street in Breckenridge was one of the first in the mining town. After completing their business in the clerk's office to the north, the men could adjourn to the National Saloon. Saloon keepers followed the miners, providing them with food, drink, and perhaps a place to sleep or a refuge from loneliness. In some saloons, it was possible to find female companionship.

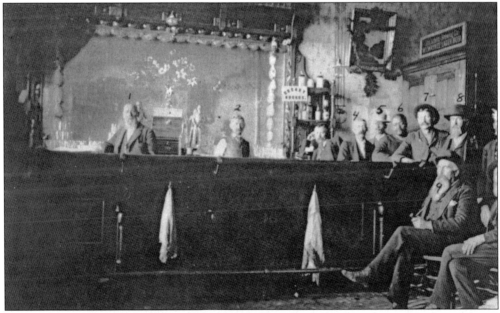

THE CORNER SALOON. The Corner Saloon, owned by John Dewers, was located on the northwest corner of Lincoln Avenue and Main Street in Breckenridge. The sign advertised Cherry Bounce, bottled and sold by the saloon. Dewers stands behind the bar (No. 2). Bob Lott (No. 6), an African American who lived in the county, is buried in the pauper's section of Valley Brook Cemetery. A plaque reads: "A loyal citizen and faithful friend."

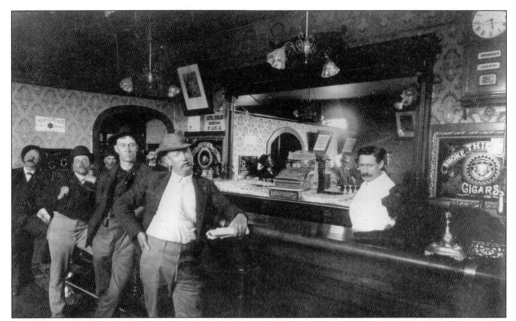

WEAVER BROTHERS SALOON. Located on the southeast corner of Lincoln Avenue and Main Street in Breckenridge after the start of the 20th century, this saloon was one of many in town. Advertising for the saloon noted that the drinks were "seductive, but seldom intoxicating." Note the ornate ceiling lights, the mirrored cigar advertisement, and the large mirror behind the bar. The clock showing U.S. Observatory time was updated hourly by Western Union Telegraph.

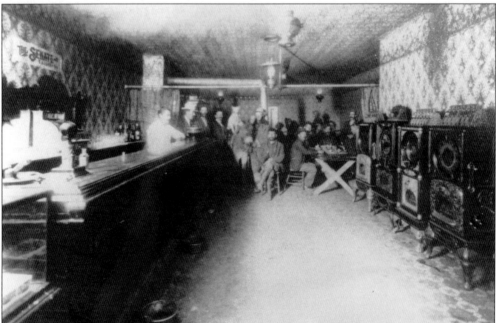

ORNATE SALOON. This photograph shows features found in many saloons, such as a tin ceiling, the bar located to the left of the entrance, a brass foot rail, spittoons, and gaming tables at the rear of the saloon. The curtain closed off the rear of the saloon. Early models of "one-armed bandits" line the wall. Note the burro with a dog on its back at the end of the bar.

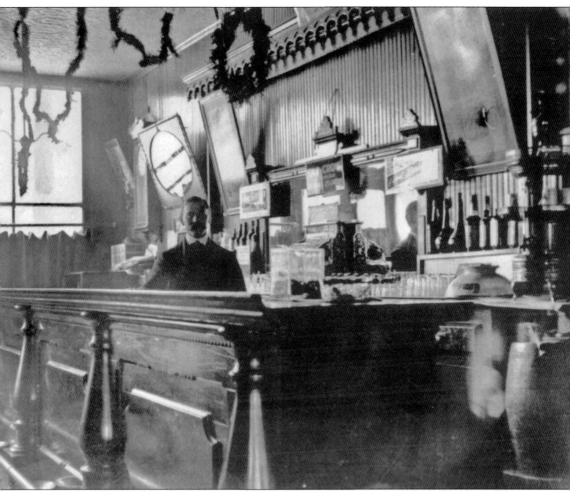

UNIDENTIFIED SALOON IN THE LATE 1880s. Notice the immaculate dress of the saloon keeper, holiday decorations, electric lights, spittoons, the brass foot rail, and the ornate cash register. Because there were no lodges or clubs early in the life of a mining town, men came to the saloons to discuss politics or read the newspapers a saloon keeper might have. Some saloons rented mail boxes or posted employment notices.

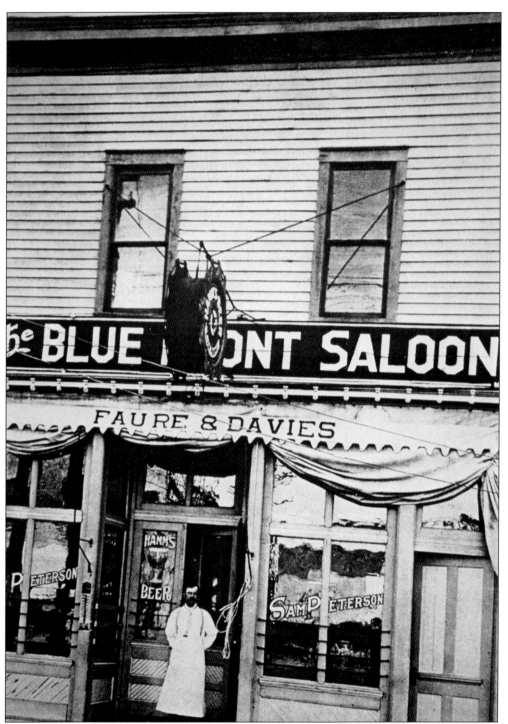

THE BLUE FRONT SALOON. The Blue Front Saloon, located on the northwest corner of Lincoln Avenue and Main Street in Breckenridge, was one of a chain of saloons owned by Sam Peterson, who held the exclusive right to sell Hamm's Beer. The beer for the saloons in town arrived by wagon and railroad. It was very rare that the supply was depleted.

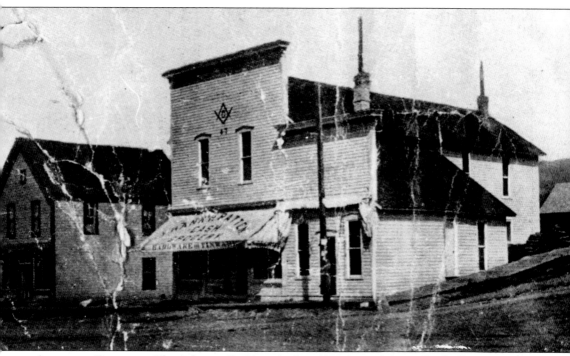

ARBOGAST BUILDING. The Arbogast Building, built in 1892, housed the medical offices of doctor and coroner B. A. Arbogast, who also served as the school superintendent. A Mason, he later leased the second floor to Lodge No. 47. The first floor was occupied by merchant Frank Patton, who sold for cash only and advertised "bedrock prices." Merchants felt stiff competition from traveling salesmen and catalogues, both arriving by train.

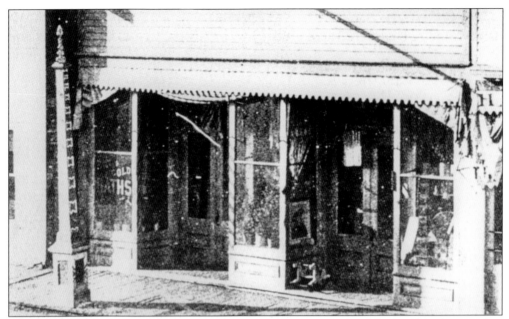

MINNIE BRUCH'S CONFECTIONARY STORE. In the northern half of the building housing her husband's barber shop, Minnie Bruch operated a very popular confectionary store. In 1882, her advertisement appeared in the *Summit County Journal* offering "fine rock candy at $.25 per pound, fine fresh fruit, an elegant assortment of fine candies, and the largest stock of Valentines in the county."

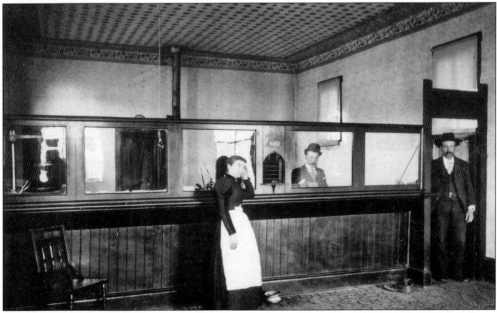

INSIDE THE ENGLE BROTHERS EXCHANGE BANK. George and Peter Engle, from Switzerland, operated a saloon and billiard parlor on the northeast corner of Lincoln Avenue and Ridge Street in Breckenridge. Eventually tiring of the business, George and Peter opened the Engle Brothers Exchange Bank on the southeast corner of Lincoln and Ridge directly across from the old saloon building, which later housed the George Siebe cigar factory.

ENGLE BROTHERS EXCHANGE BANK. The Engle Brothers Exchange Bank operated in the old Bank of Breckenridge building until 1936. George married Gertrude Briggle, a schoolteacher from Montezuma and Breckenridge, and the sister of William Briggle, a teller in the bank. The Engles made the second floor of the bank their home.

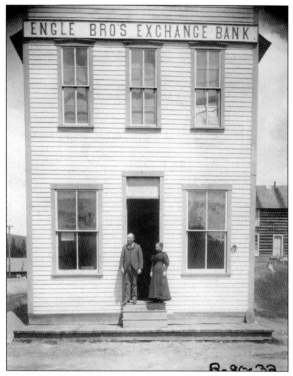

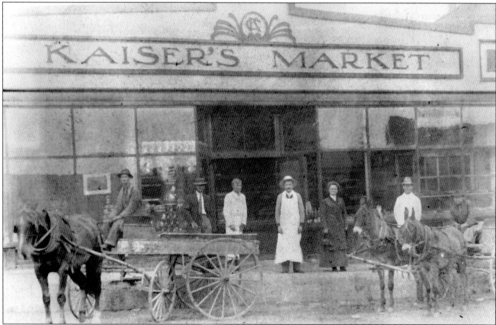

KAISER'S MEAT MARKET. Christ Kaiser, a German immigrant, operated a meat market on Lincoln Avenue in Breckenridge that was known for fine meats and German sausages. His advertisement read, "Choicest meats, poultry, fish, etc., everything that you would expect to find in a first-class market." Kaiser was the president of one of several German singing societies in Breckenridge, an indication of the large number of German immigrants residing in town.

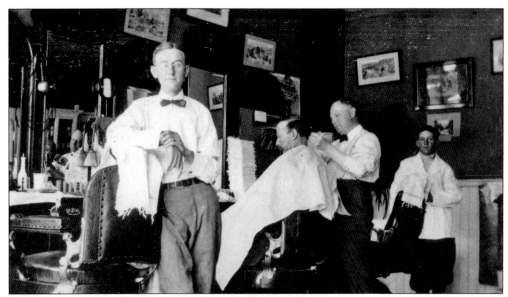

Torkington's O. K. Barber Shop. This shop was located on Main Street in Breckenridge next to the Denver Hotel. An advertisement in a newspaper in 1911 showed that German speakers were still an important part of the population of Breckenridge and Summit County. It read, "Wenigzusagenabergutesarbeitzugeban is our motto." Translated it means that he has little to say but good work to give.

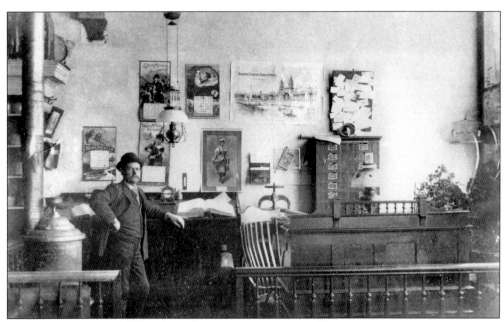

Office in Finding's Hardware Store. Heated by a coal-burning stove and lighted by gas lamps, the office of Finding's Hardware Store is where the accountants sitting at their desks maintained company records. On the wall are numerous calendars, one with an 1890s pin-up girl. Two advertise Union Metallic Cartridges and another Winchester Ammunition.

TOOLEY'S STORE. Tooley's offered boots, shoes, and clothing for gentlemen in Breckenridge in 1898. Those who could afford to dress fashionably looked for stores such as this to purchase their clothing. There were specialty shops offering the same services to the women of higher society in town. Railroads brought the latest fashions that the people were eager to purchase if the price was right.

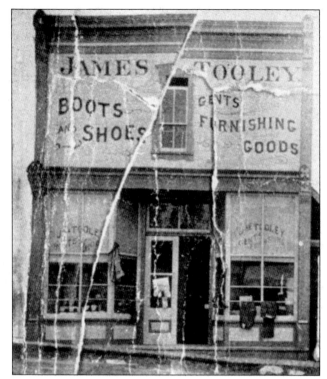

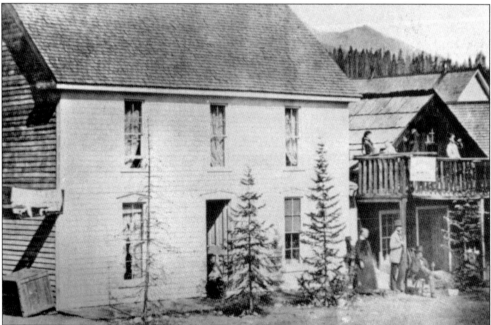

THE SILVERTHORN HOTEL. Like many who came from the East Coast, the Silverthorn family migrated from Pennsylvania and, in 1860, opened their hotel in the one-and-a-half-story building to the right. When the hotel became a favorite stopping place for visitors, Marshel Silverthorn bought the two-story building next door. His wife, Agnes Ralston Silverthorn, was the much-loved hostess of the hotel, which also housed the post office.

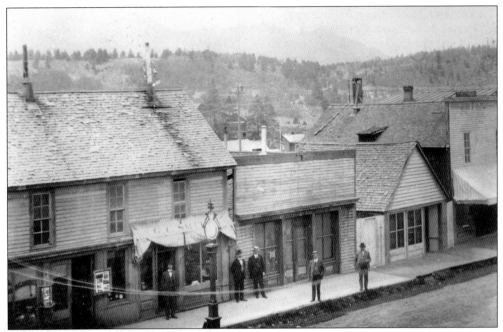

SMITH'S JEWELRY STORE. After the death of Agnes Silverthorn in 1883 and her husband, Marshel, in 1887, the hotel housed numerous businesses. Among them was the jewelry store of George C. Smith. In addition to fine jewelry, Smith sold cut glass and decorated china. The famous photographer Otto Westerman had his shop to the left of the jewelry store. At one time, the building housed Barney Ford's Saddle Rock Café.

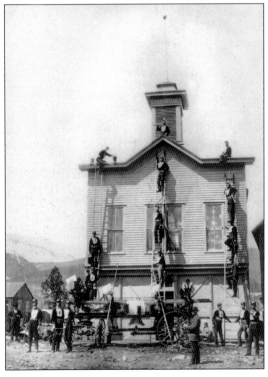

FIRE HALL ON FRENCH STREET. Three fire companies served Breckenridge: the Pioneer Hook and Ladder Company (Red), the Independent Hose Company (White), and the Blue River Hose Company (Blue). Collectively they were known as the Red, White, and Blue Fire Company. The bell was purchased in April 1881 and the hose and hose cart in the fall of 1882.

FIREMEN'S HALL. THE Independent Hose, the Pioneer Hook and Ladder No. 1, and the Blue River Hose Companies made their home in Fireman's Hall. The names were painted on their respective doors. Originally located on French Street, the building, erected in 1880, was moved to its Main Street location during December 1887 and January 1888. A system of taps on the bell in the belfry told which company was being called to service.

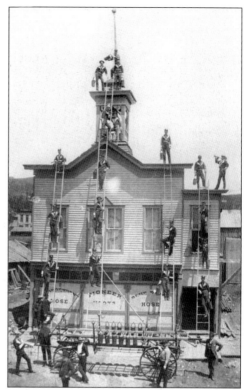

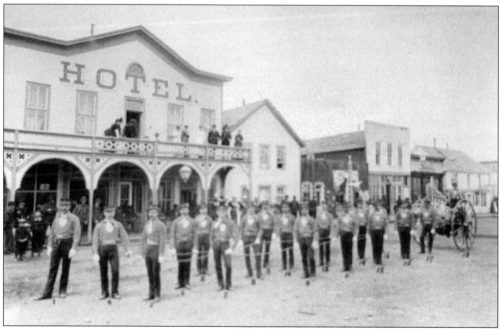

BLUE RIVER HOSE COMPANY. Firefighters in the company pose in front of the Denver Hotel in this pre-1899 photograph. The men are pulling their hose cart along Main Street. The wide street was often the scene of games between the three companies in town. Each wanted to prove it had the strongest men and swiftest runners who could quickly extinguish a fire.

COUNTY CLERK'S OFFICE. When the county commissioners decided to move the county seat from Parkville to Breckenridge in 1862, a building was constructed to house the office of the county clerk and recorder. Located on North Main Street, the building contained the offices of other county officials as well.

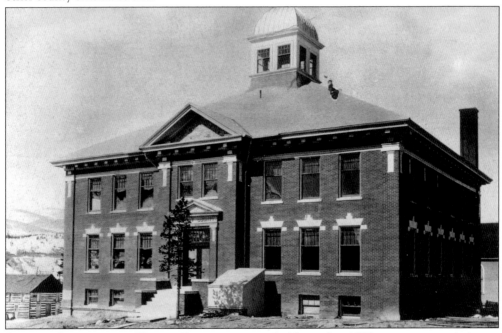

COUNTY COURTHOUSE UNDER CONSTRUCTION. In November 1908, county commissioners authorized an indebtedness of $75,000 for the construction of a new courthouse. The site chosen was Lincoln Avenue between Ridge and French Streets. In the pediment on the roof of the building a mural made of zinc depicts a mining scene. The shed beside the steps stored tools.

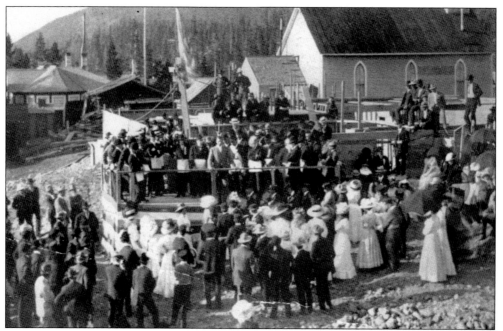

LAYING THE CORNERSTONE. In the copper cornerstone box rests a copy of the resolution authorizing the construction of the courthouse, local newspapers, and gold nuggets. The cement used to seal the box and lay the cornerstone, made of Colorado granite, held a quantity of gold dust. In the background is Father Dyer Methodist Church, which at that time sat next to the courthouse.

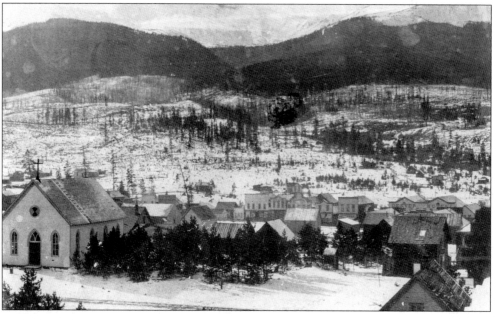

ST. MARY'S CATHOLIC CHURCH. Originally constructed in 1881 and located at the corner of High Street and Washington Avenue, the church found a permanent home on French Street between Lincoln and Washington Avenues in 1890. Note the fire ladder on the church roof. The barren hills west of town were cleared for the lumber needed in mines and mills, and for buildings and fuel.

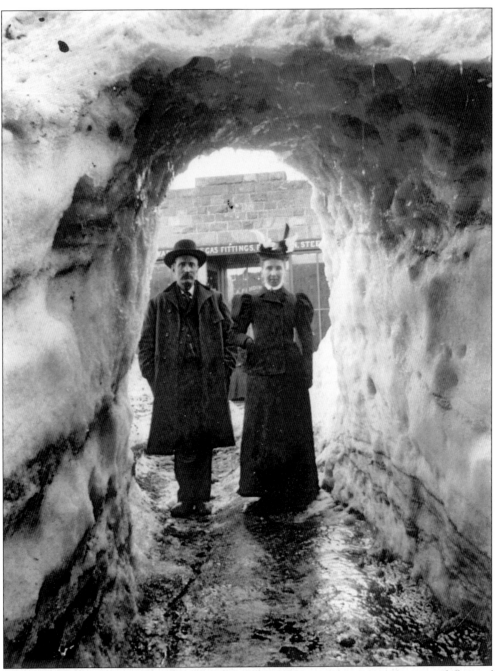

SNOW TUNNELS. During the winter of 1898–1899, snow depths reached the second floor of buildings along Main Street. Snow tunnels allowed people to cross from one side of the street to the other. Banker George Engle and his wife, Gertrude, are pictured using one of the tunnels on Main Street. Behind them is Finding's Hardware Store.

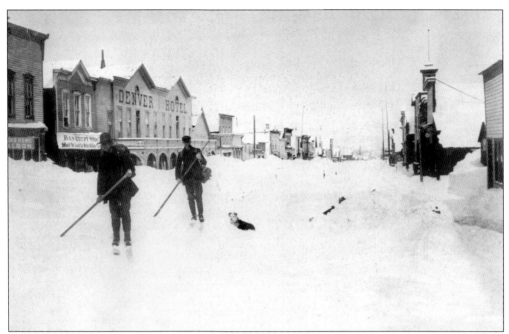

MAIL CARRIERS. Carrying the mail presented a challenge during the winter of 1898–1899 when snow began falling the first week of November and continued through June. From February 4 until April 24, no trains ran over Boreas Pass. Mail was carried by men on skis and snowshoes. Volunteers dug out the road over Boreas to Como so that supplies could reach the towns and camps.

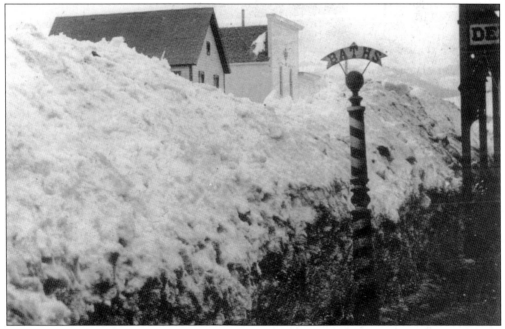

BARBER POLE ON MAIN STREET. In 1880, Fred Bruch operated a barbershop and cigar store in Breckenridge directly north of the Denver Hotel. In 1881, he added hot and cold baths to the barbershop. Even during the winter of 1898–1899 when snow covered the streets to great depths, men came for their weekly bath. To have hot water for the baths was considered quite a luxury.

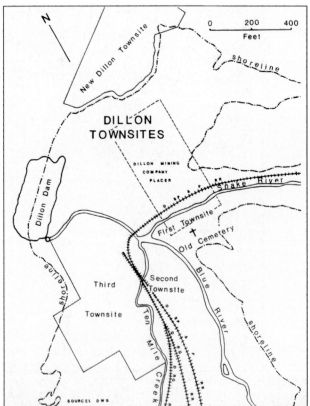

DILLON TOWN SITES. Since its founding, Dillon has moved three times. First platted straddling the Snake River, the town moved twice to incorporate the tracks of both railroads within the town site. The last move was dictated in 1961 when Dillon Reservoir flooded the first three town sites.

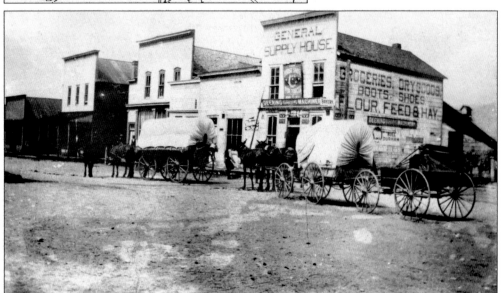

AGRICULTURAL SUPPLY TOWN. In the 1880s, Dillon functioned as a supply point for the area, receiving and distributing agricultural goods and supplies. Wagon trains brought tons of supplies to merchants each day. A sawmill provided lumber for buildings. A newspaper reporter predicted in 1883 that the area had a future serving tourists. He wrote that the town had broad avenues and roomy streets with nearby meadows filled with wildflowers.

THIRD DILLON TOWN SITE. Although this untitled, undated map of the third town site showed many streets and avenues, the town never occupied all of them. Although it began as a mining town platted by the Dillon Mining Company, the town functioned as a transportation hub and a supply point for ranchers in the lower Blue River Valley.

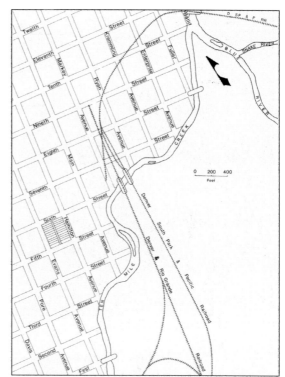

WATER PUMP IN DILLON. After the dawn of the 20th century, Dillon had two principal north-south streets. Most of the businesses were on Main Street. There were four saloons, one pool hall, two general stores, a butcher shop, a drugstore, a barbershop, two blacksmith shops, a doctor's office, two hotels, the post office, and two newspaper offices in town. The small wooden structure covered the town's water pump.

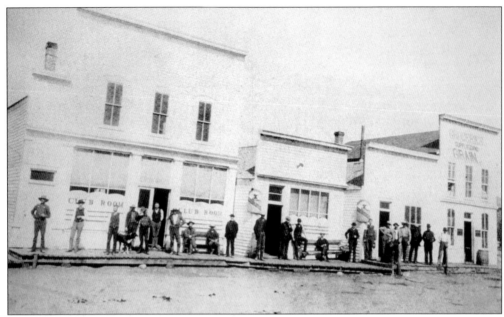

THE JAMES RYAN CLUB ROOM. Dillon was founded in 1881 by the Dillon Mining Company, led by Orahood, Sayr, and others of Denver. The town was named for Sydney Dillon, president of the Union Pacific Railroad. The newspaper editor in Dillon called the Club Room, one of four saloons in town, "worthy of a call from the thirsty."

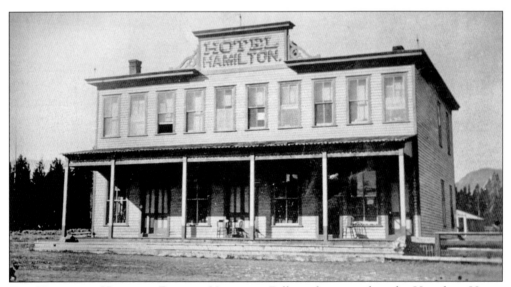

THE HAMILTON HOUSE IN DILLON. Visitors to Dillon often stayed in the Hamilton House located on Hamilton Avenue, called "Back Street" by local residents. Built by the town company and managed by Thomas Hamilton, the Hamilton House was described as an "elegant building, a handsome structure and a credit to the enterprise of the town company."

THE *DILLON ENTERPRISE*. Every town wanted a newspaper. The *Dillon Enterprise,* which began publication in 1882, reported the happenings in Dillon. O. K. Gaymon, the editor, and his wife, Augusta, lived in this building that housed the newspaper. In 1897, the staunch Republican Gaymon became editor of the Democratic *Summit County Journal* in Breckenridge, serving as editor until September 25, 1909.

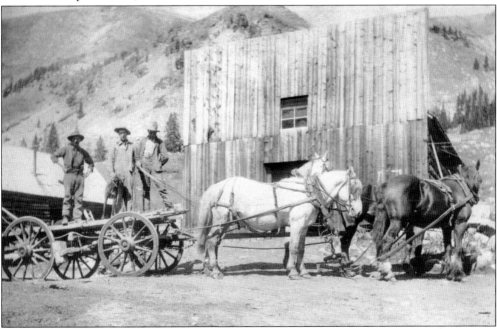

ROUGH-SAWN BUILDING ON PERU CREEK. Because of the need for large amounts of sawn lumber, sawmills brought by wagon dotted the landscape. Horse-drawn wagons carried the lumber to sites such as this where vertical boards were simply nailed onto wooden frames. Even in hastily constructed buildings, the false front with space for advertising was common.

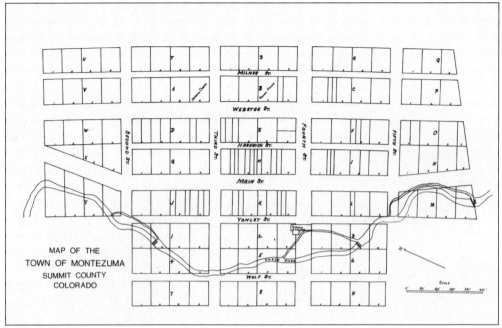

UNDATED MAP OF MONTEZUMA. Probably drawn during the 1880s, the map shows the grid pattern so typical of streets in Rocky Mountain mining towns. The town straddled the Snake River. Space was saved for the schoolhouse and Catholic church when the town was platted. The Sisapo Smelter used water diverted from the Snake River in its operations.

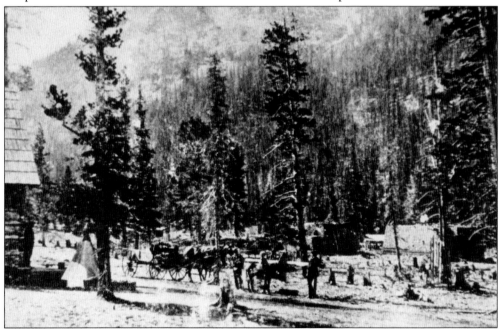

MAIN STREET. In September 1876, the main street of Montezuma was nothing more than a pathway cleared of trees. Note the piles of wood cut for lumber and fuel, the teepee under the tree, and the hay and straw for feed. The town's population grew to 56 by 1880: 47 men and 9 women. Surrounded by silver mines, the town expanded to 159 by 1885: 111 men and 48 women.

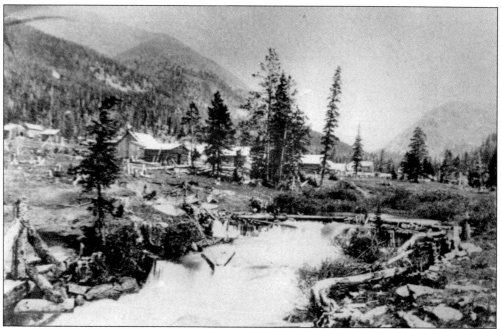

MONTEZUMA. William Brewer wrote in 1869: "At last we came to the town of Montezuma, whose newly shingled roofs gleamed through the trees. . . . New houses were going up. . . . We stopped at the only hotel. . . . The house was without chairs. . . . It had three rooms downstairs—the sitting room, dining room, and kitchen. . . . We slept in a common garret."

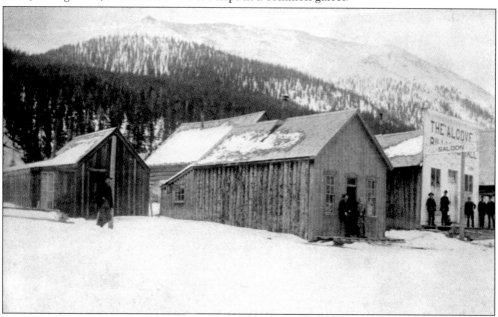

THE ALCOVE BILLIARD HALL AND SALOON IN MONTEZUMA. This business was one of many that operated in the silver-mining town of Montezuma. The nearby town of Sts. John, founded by the Boston Mining Company, allowed no saloons. Workers walked or rode their wagons to Montezuma for their liquid refreshment. Settled in 1865, Montezuma was named for the Aztecs' last emperor.

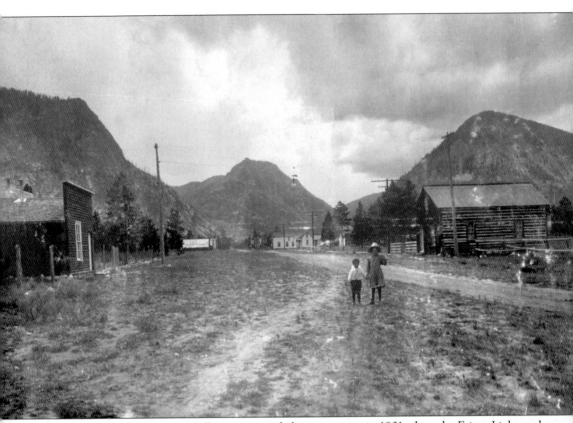

MAIN STREET, FRISCO, 1889. Frisco acquired electric service in 1901 when the Frisco Light and Power Company produced electricity for the town. Lights were erected at several intersections along both Main and Galena Streets. Telephone service came to Frisco by September 30, 1905. The switchboard in Brown's Store served two stores, Brown's and Nilander's, and two mines, the Excelsior and Admiral. Note the electric light over the roadway.

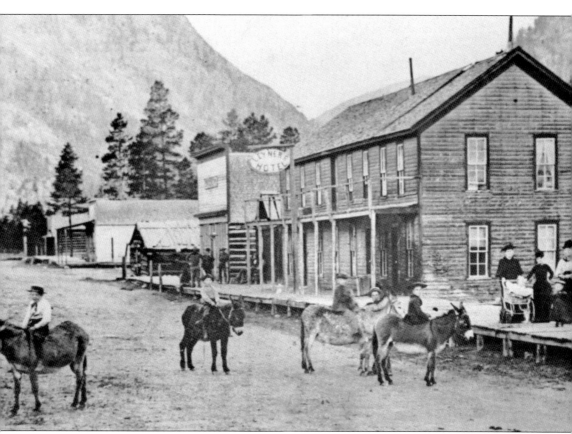

LEYNER'S HOTEL, FRISCO. Visitors to Frisco in the late 1880s and early 1890s could stay in Leyner's Hotel, one of several hotels and boardinghouses in town. With a population of about 35 in 1885, the town served as a gateway to the mines of the Ten Mile Canyon. Typical of Rocky Mountain communities, a mayor and board of trustees governed the town.

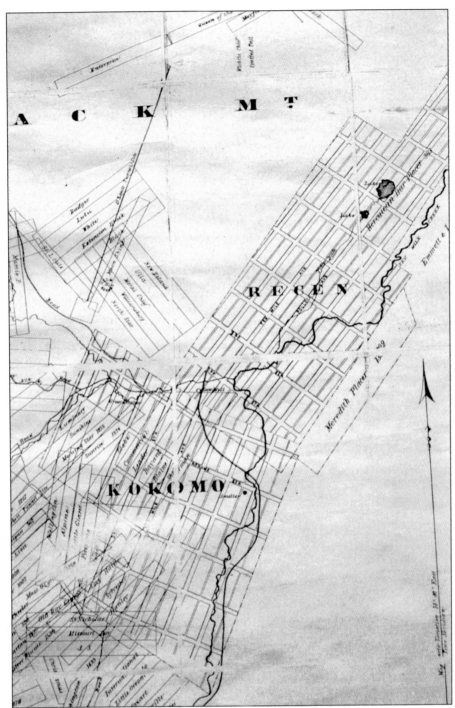

KOKOMO-RECEN. Speculators platted these towns amid the mining claims to the west of the Ten Mile Creek. After Kokomo suffered a devastating fire fueled by powder and cartridges in the stores on October 13, 1881, the towns consolidated. Recen hired a fire marshal to inspect buildings, chimneys, and stoves. If there were problems, he ordered immediate repairs or levied fines until the problem was corrected.

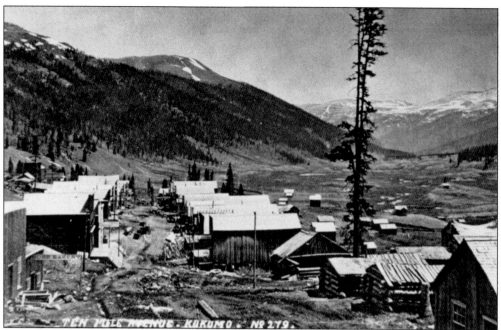

TEN MILE AVENUE IN KOKOMO. The town company offered free lots to anyone who would build on them. Homes were interspersed among the businesses along the street. Kokomo was large enough to support specialty shops: two sign and house painting companies, two confectioners, several bakeries, four drugstores, and five stores selling men's clothing.

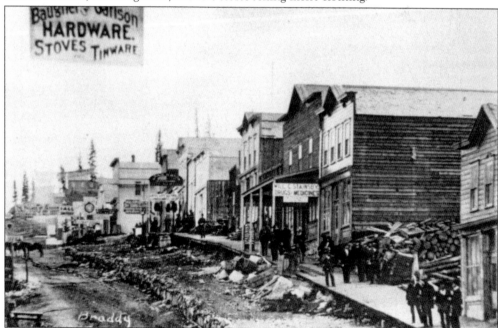

KOKOMO. The town served as a supply center for miners in the Upper Ten Mile. False-front wooden buildings faced trash-littered streets. The signs read Palace of Fashion, G. A. R. (Grand Army of the Republic) Hall, clothing house, fancy staple dry goods, and dressmaking. Each merchant was responsible for keeping one-half of the street in front of his or her business free of litter.

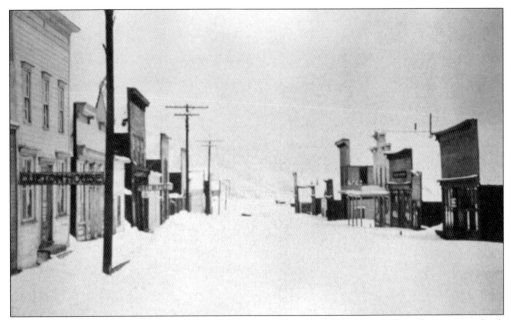

KOKOMO IN WINTER. Snow covered the garbage and litter in the town. When the snow melted, the problems reappeared. It was the duty of the town marshal to rid the town of the sewage, dead animals, and garbage. Fines were high. For sewage, the fine was $2 to $5 for each 48 hours the problem continued; for garbage and dead animals, $5 to $50 per offense.

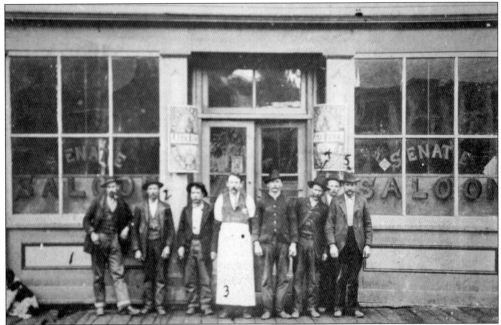

THE SENATE SALOON. Owned by Sumner Whitney, the saloon was located in Recen on Ten Mile Avenue between First and Second Streets. Here, according to the signage, patrons drank Anheuser-Busch Beer. Sumner, with the large apron, was a county deputy marshal. When he was killed in a shoot-out with Pug Ryan's gang, his wife, Martha, operated the saloon, a rare occupation for a woman.

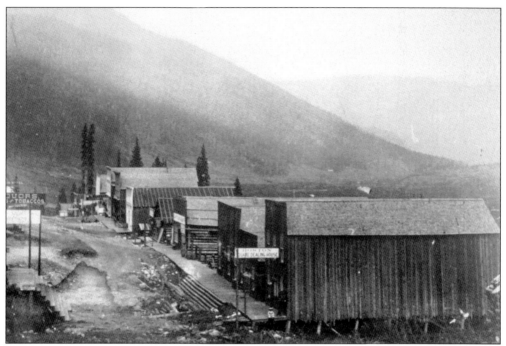

THE GRAND CENTRAL HOTEL IN KOKOMO. The hotel (left foreground) was one of many that lined Ten Mile Avenue in Kokomo in 1879. Saloon and hotel keepers advertised cigars and tobacco, as well as whiskey. Inside men enjoyed games of chance such as euchre, seven-up, cribbage, faro, monte, roulette, and keno while drinking "rot gut" as often as real whiskey.

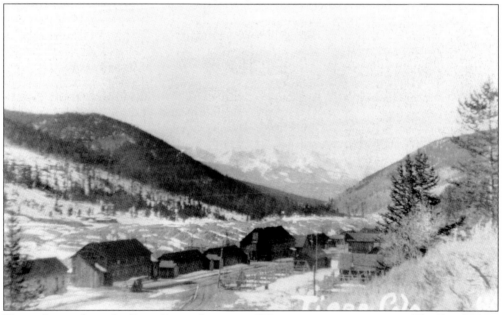

TIGER. Located on the Swan River, the town of Tiger was a company town. The Royal Tiger Mining Company claimed to be unique in its concern for the miners' health and welfare. Created after 1900, the town boasted homes for the miners, a rooming house, an electric plant, a steam heating plant, medical facilities, mining offices, and a school.

TIGER SCHOOL. Advertisements attracting workers to the town of Tiger focused on the educational opportunities available to the children: "The Tiger School is on the highest grade, founded on the idea that Education is the hope of the future. Be a Tiger." The school with its playground was located on the north side of the Swan River.

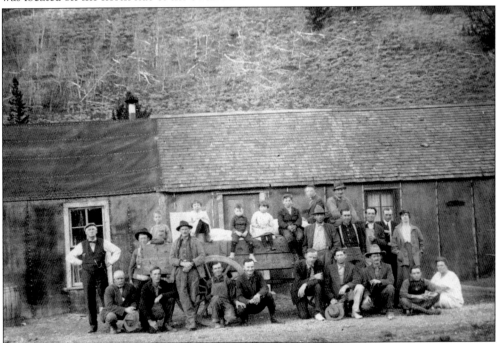

HOME OF THE FAMILY MAN. In Tiger, married men, because of added financial responsibilities, always received higher pay than single men for the same job. Families were entitled to a two-, three-, or four-room unfurnished house for $10 per month. This included fuel and electricity. Furnished rooms for single men cost $4 per month. For entertainment, the company provided free movies and dances every week.

Four

LIFESTYLES IN THE VICTORIAN ERA

The Victorian era blossomed in the 1880s and 1890s in Summit County. The newspapers published accounts of balls, dinners, weddings, social gatherings, and other notable events. For dinner parties given by the socially prominent, the editor noted who attended, who wore what down to the last button and bow, what food was served, house and yard decorations, the games played, the scores and prizes awarded, and the winners of those prizes. No hostess was a failure; they were all the finest to be found anywhere.

Families attended "sociables" at the churches. Young and old alike enjoyed ice cream and strawberry festivals. Card parties were popular, as were events at the theater such as plays, lectures, and musical concerts.

Some of the most important events were the balls given throughout the year by various lodges and social clubs. People needed little impetus to plan them. While many enjoyed the welcome diversion, some ministers considered balls and dances the work of the devil and frowned upon those who hosted and attended the events.

Stores competed with each other to provide the latest in fashions. Those with time and talent designed their own gowns based on what they saw in pattern books and magazines.

In the 1890s, women sent ornately decorated calling cards to each other. At specified times, these women were "at home" to receive guests. Men and women observed very strict rules of etiquette during these visits.

Despite the relative isolation of the county, those whose social status would permit it enjoyed all of the social trappings and obligations of the era just as did those living in the large cities along the East and West Coasts of the United States.

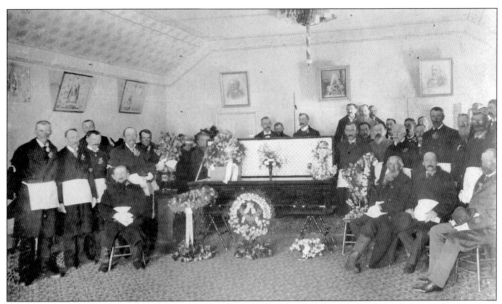

EDWIN CARTER. Edwin Carter came to Summit County in 1868 to search for gold. Realizing that the chemicals used in the mining processes were taking a toll on the county's animals, he used his taxidermy skills to preserve hundreds of specimens and opened a museum in the cabin he built in 1875. He helped organize the Breckenridge Masonic Lodge in 1881. His funeral service was conducted by that lodge.

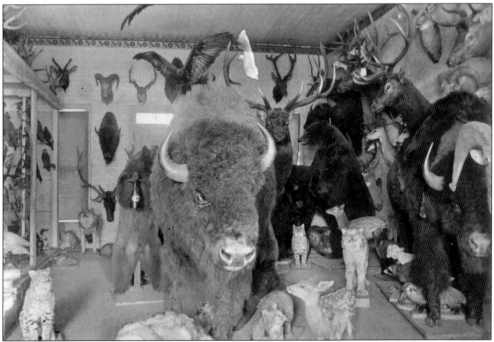

ANIMALS IN CARTER MUSEUM. Edwin Carter collected hundreds of specimens for his museum on Ridge Street in Breckenridge. Behind the bison is a bear holding a wine bottle in its right paw. In its left paw, but not seen in this picture, it held a wine glass. At Carter's death in 1900, most of his collection was given to the Denver Museum of Nature and Science.

BARNEY FORD. Barney Ford was a mulatto, born a slave in 1822. He escaped to Chicago where he met his wife, Julia. Seeking his fortune in gold, he eventually came to Colorado. Famous as a hotel and restaurant proprietor, he worked to assure that civil rights for African Americans were included in Colorado's constitution. For his work, Barney has a place of honor in the state capitol in Denver.

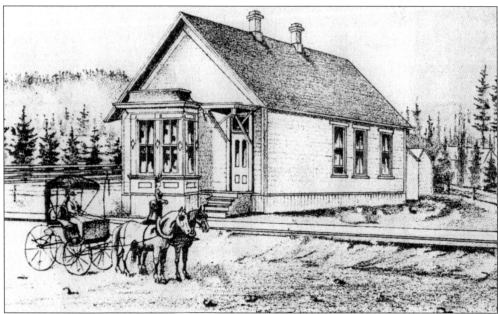

BARNEY FORD HOUSE. Built by Elias Nashold in 1882 for the Barney Ford family, the house featured the bay window common to houses built by Nashold. Barney operated the Ford Chop House at the corner of Washington Avenue and Main Street, and later the Saddle Rock Café on Main Street. Because the family's food was prepared in the restaurants, the house as originally designed had no kitchen.

JOHN LEWIS DYER. Dyer, an ordained Methodist minister, came to Colorado to see "gold country" before an eye problem took his sight. He began his ministry in 1862 as a circuit rider, conducting services in homes, saloons, tents, and the open air. After building a church in Breckenridge in 1880, he left full-time preaching and resumed circuit riding and part-time preaching until his death in 1901.

Pug Ryan. L. A. Scott, alias Pug Ryan, and his gang entered the Denver Hotel in Breckenridge around midnight on August 11, 1898, intending to empty the hotel's safe. Instead they robbed the individuals who had been gambling. After the gang escaped, they were involved in a deadly shoot-out in which Sumner Whitney, a saloon keeper from Kokomo, was killed. Some of the loot was recovered 10 years later.

Lula and Dimp Myers. Lula came to Summit County as a schoolteacher in Frisco. She and her husband, James H. ("Dimp") Myers Jr., lived in this 1885 log house that was part of the Delker Ranch in Keystone. They purchased the home in 1924. After Dimp died in 1954, Lula lived in the house until 1966. Lula and Dimp are second and fourth from the right in the photograph.

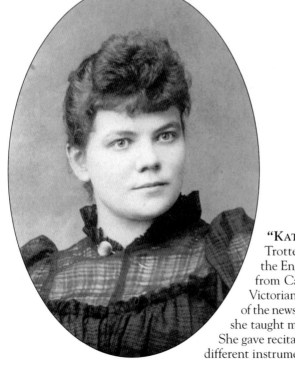

"Kate" Trotter Briggle. In 1896, Kate Trotter married William Briggle, a teller in the Engle Brothers Exchange Bank. Originally from Canada, she was a proper matron of the Victorian era mentioned often in the society pages of the newspaper. Recognized for her musical talents, she taught many children in town to play the piano. She gave recitals of her own, sometimes playing several different instruments during a concert.

SWANS NEST. Ben Stanley Revett introduced gold dredges and gold dredging to Summit County in 1898. His home, Swans Nest, constructed in less than two months, was on the north side of the Swan River about a mile from where the river enters the Blue River. The wings of the home were said to embrace the view of the Ten Mile Range to the west.

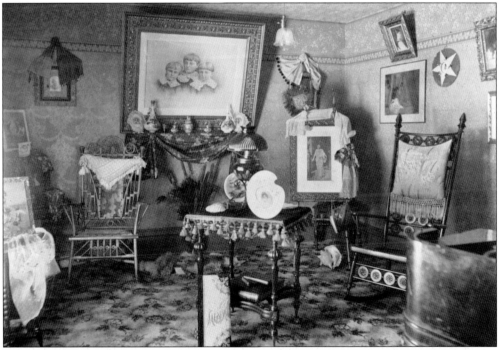

FINDING RESIDENCE ON MAIN STREET IN BRECKENRIDGE. As was typical of Victorian homes, the rooms and their décor were lavish. Seemingly every square inch was filled. Clustered furniture created a sense of intimacy. Walls were papered and hung with pictures and other items. Martha Finding was a member of the Order of the Eastern Star. A symbol of her membership hangs on the wall.

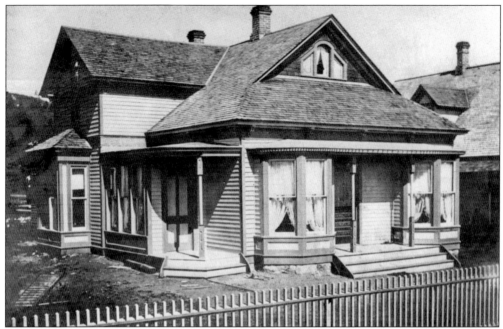

THE OREN K. GAYMON HOUSE. Built in 1898 for his wife, Augusta, when O. K. Gaymon became the editor of the Breckenridge newspaper, the home had three bay windows that provided light to the interior. A member of the socially elite in Breckenridge, Augusta owned a large collection of cut-glass pieces and decorated china.

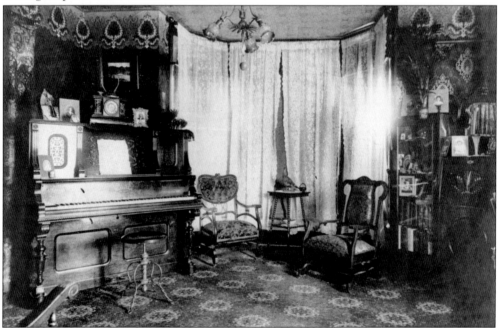

VICTORIAN HOME. Like many homes of this time period, this one in Breckenridge featured a variety of textures and patterns on every surface. Music was an integral part of every young lady's education. It was thought that such training would help her find a suitable gentleman for a husband.

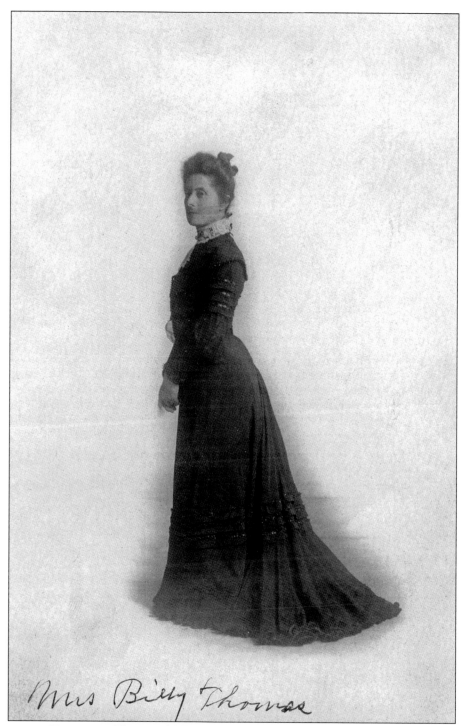

Mrs Billy Thomas

VICTORIAN ELEGANCE. The social life of the county flourished during the 1890s. Reports of balls and socials filled the newspapers. Cut-glass dishes and the finest china and crystal glassware graced the tables of the wealthy. Those who cold afford them wore the latest fashions. The wife of Judge William Thomas displayed the height of fashion in this gown.

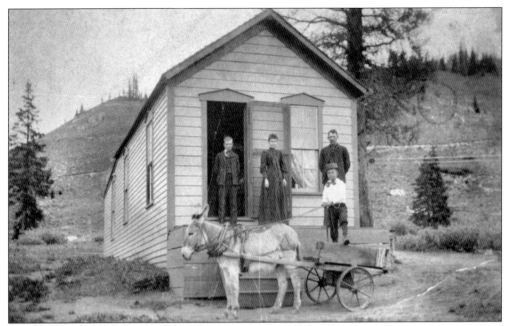

TURNER HOUSE IN KOKOMO. Dressed for the photograph, the family stands in front of one of the more well-constructed homes in Kokomo. Sawmills in the area provided sawn lumber for homes such as this. The young boy with his burro cart carried home goods from the many grocery and hardware stores in town. Perhaps he offered friends a ride.

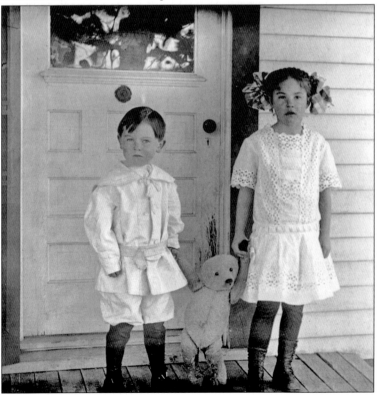

WELL-DRESSED CHILDREN. Generally boys and girls dressed alike for the first few years of their lives. At about the age of six, children started dressing as adults. In wealthy families, mothers purchased velvet suits and silk stockings for the boys. For the girls, they bought ruffled pantaloons and hoop skirts. If a family could not afford expensive clothing, boys wore muslin shirts while the girls dressed in cotton or muslin.

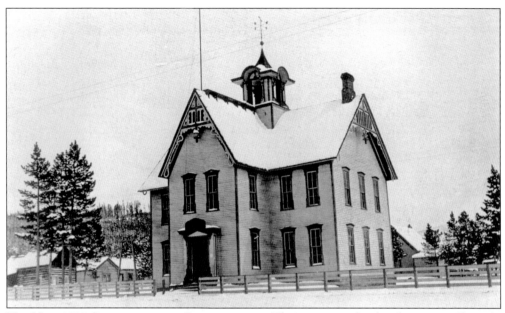

THE NEW 1882 SCHOOLHOUSE IN BRECKENRIDGE. The two-story school at the corner of Lincoln Avenue and Harris Street contained four classrooms. At first only two were furnished for use. The newspaper editor hoped that men teachers would be employed as well as women because some of the pupils responded better to the strictness of male teachers.

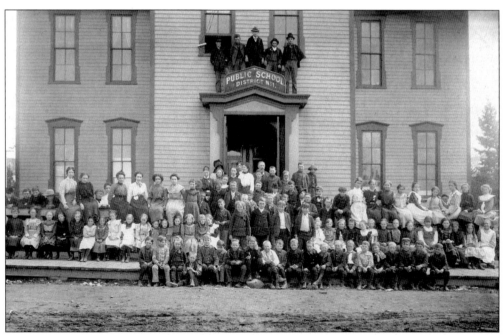

THE 1882 SCHOOL. These students, shown with their teachers, attended the 1882 Breckenridge School in 1901. The town sold $7,000 in bonds to purchase the land and finance the construction of the school. Although there were male teachers in the county, many of the teachers were women because teaching was considered an extension of their role as mothers and they would not be deterred by low wages.

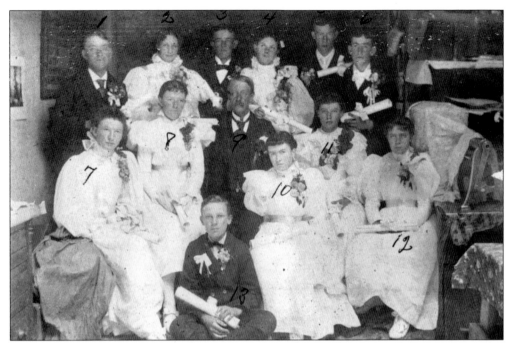

GRADUATING CLASS, C. 1897. Twelve members of a graduating class pose with their male teacher, who is in the center of the group. The photograph was most likely not taken in a school building. Note the covered furniture and machinery that surround the group.

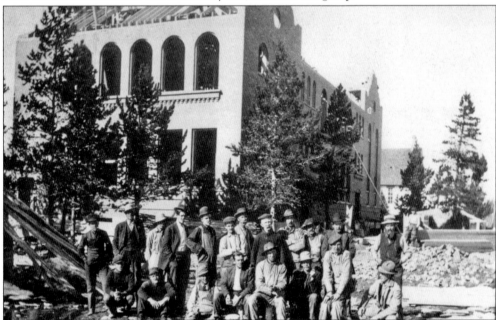

THE 1909 SCHOOL IN BRECKENRIDGE. This brick Spanish mission–style building under construction was the third school to be built in Breckenridge. Bonds totaling $20,000 financed the construction. This structure replaced the two-story wooden 1882 school that had been constructed on an adjacent lot to the north. The newspaper editor gushed that students in town would receive an education on par with Denver and Colorado Springs.

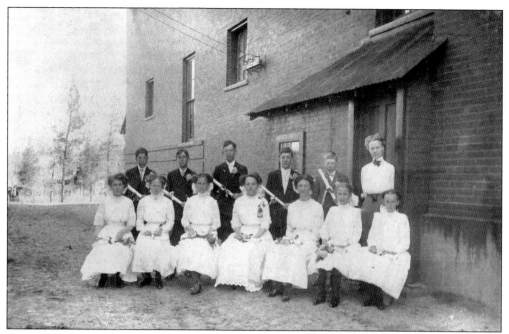

EIGHTH-GRADE GRADUATING CLASS. Twelve eighth graders graduated in 1911 from the recently constructed brick school in Breckenridge. Their teacher stands at the right in the second row. With the construction of this school, children were able to complete all 12 grades without leaving the county instead of only receiving instruction up to grade 10.

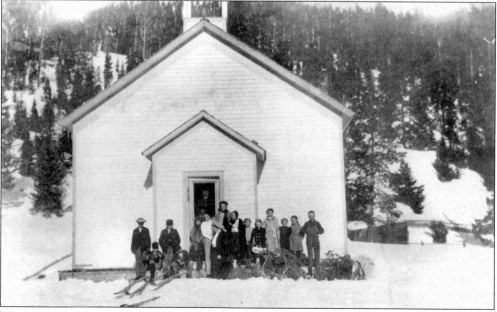

MONTEZUMA SCHOOL, C. 1910. This schoolhouse, the second in town, served children living in Montezuma and neighboring Sts. John from 1884 until 1958. A log building directly in front of this schoolhouse housed the town's school from 1880 until 1884. Because of heavy snow, school might not be in session during winter months. Children in the first eight grades were taught in one large room by one teacher.

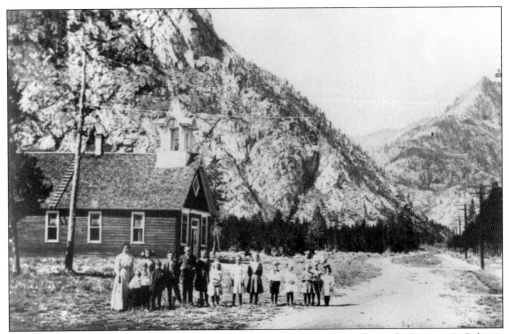

THE FRISCO SCHOOLHOUSE IN THE 1890S. The Frisco School was formerly Swanson's Saloon. When the saloon became bankrupt during the silver panic of 1893, the owners sold it to the town for use as a schoolhouse. Note the ladder on the roof. Fire ordinances in some towns required that a ladder be placed on the roof in case of a chimney fire.

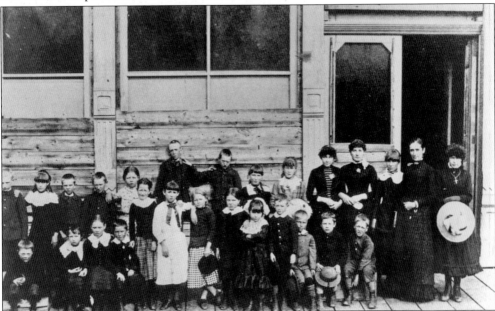

KOKOMO SCHOOL IN TEN MILE CANYON, 1886. Those wishing to teach in county schools completed a teacher's examination that was offered four times each year at the school superintendent's office. The test contained questions on science, grammar, the classics, mathematics, geography, and the history of the world, United States, and Colorado. The newspaper published the scores of those taking the examination.

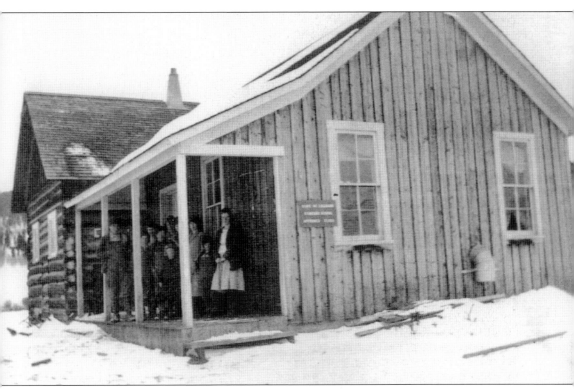

SLATE CREEK SCHOOL. Surrounded by an agricultural landscape, Slate Creek School served the children from neighboring ranches in northern Summit County. The teacher, shown with her students, probably performed additional duties, such as carrying water, chopping wood, lighting lamps, and keeping the wood stoves burning as part of her official duties.

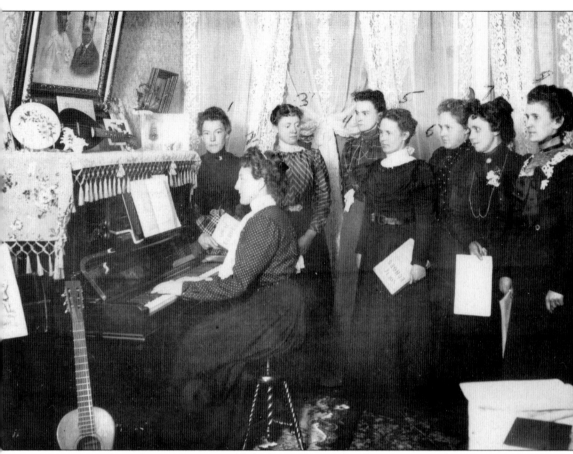

WOMEN'S GLEE CLUB. Women established numerous clubs when they arrived in Summit County. Besides singing groups, women founded card clubs, as well as kitchen and thimble clubs. There was even a taffy club! Because many left family and friends behind when they moved to Summit County, women quickly developed new networks to overcome isolation. Clubs such as these provided a way to make friends and feel welcome.

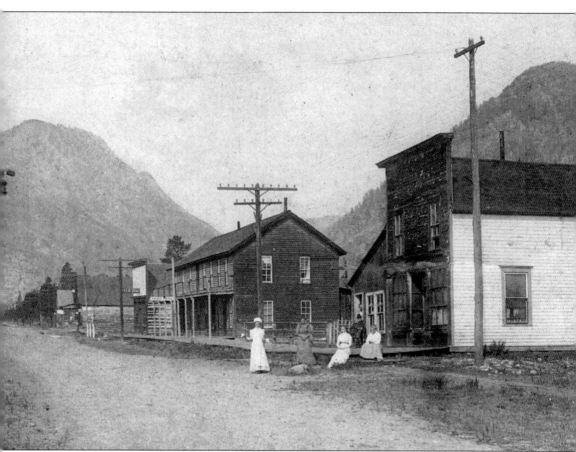

WOMEN ON MAIN STREET IN FRISCO. The 1880 U.S. Census listed 48 people living in Frisco: 39 men and 9 women. On the special 1885 Colorado census, there were 35 inhabitants recorded: 31 men and 4 women. Note the electric poles and electric light over the roadway, indicating that these women were posing after 1901.

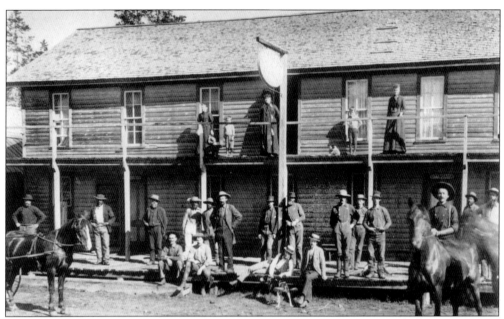

A POPULAR PICTURE SPOT. Leyner's Hotel in 1889 was a popular spot for men, women, children, and dogs. Men who came west without their wives stayed in boardinghouses and hotels such as Leyner's, where meals and lodging were available. The number of men compared to the number of women in the picture reflects the imbalance in most mining towns and camps. Men far outnumbered women.

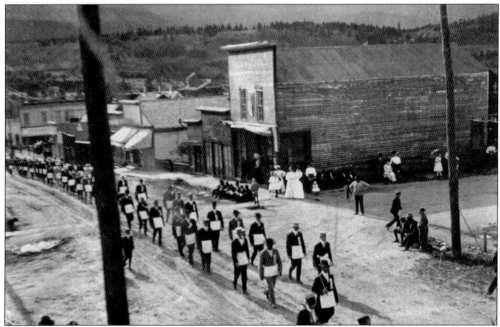

MASONS MARCHING TO COURTHOUSE DEDICATION. A column of 75 Masons in full regalia from the Breckenridge and neighboring lodges marched to the courthouse on July 31, 1909, for the laying of the cornerstone. Businesses closed for the day so that all could attend the ceremony. That evening, a ball was held at the Grand Army of the Republic Hall on Main Street.

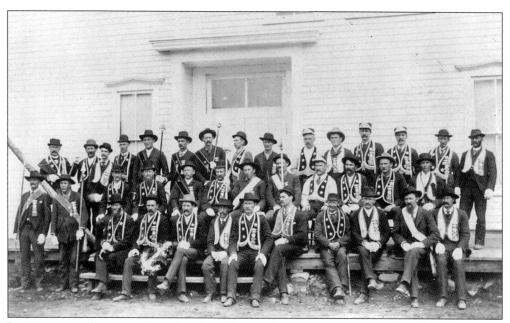

INDEPENDENT ORDER OF ODD FELLOWS. Fraternal organizations such as the Odd Fellows were an important part of the life of Summit County. These organizations filled a need during a time of great social change. Many immigrants to Summit County belonged to fraternal organizations at "home" and continued that membership upon their arrival in Colorado. These organizations provided benefits for members by caring for the sick and burying the dead.

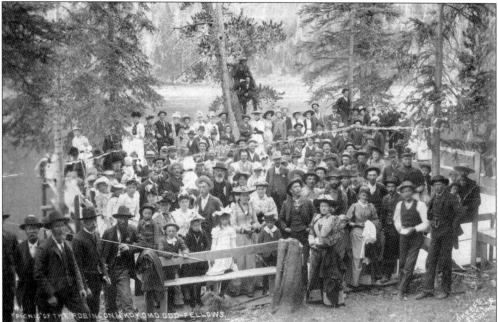

ODD FELLOWS AT UNEVA LAKE. Members of the Odd Fellows lodges in Robinson and Kokomo gathered for this photograph while enjoying a picnic at Uneva Lake, a resort developed in the Ten Mile Canyon by the Denver, Rio Grande Railroad around 1900. Odd Fellows lodges were active in Dillon, Breckenridge, Robinson, and Kokomo.

GRAND ARMY OF THE REPUBLIC. The Grand Army of the Republic was created to care for Civil War veterans and their families. Membership was limited to honorably discharged veterans of the Union army, navy, marine corps, and Revenue Cutter Service who served between April 12, 1861, and April 9, 1865. Veterans in Breckenridge formed the Joseph A. Mower Post on April 26, 1883.

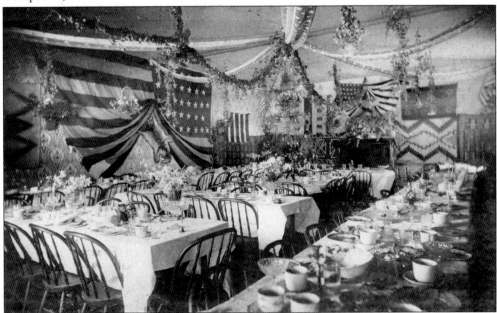

THE DECORATED INTERIOR OF THE G. A. R. HALL. The G. A. R. Hall hosted many social functions. When the organization bought the building on Main Street in Breckenridge in July 1884, the newspaper editor boasted that for "theatrical performances, shows, lectures or public meetings and balls it will be far superior to anything heretofore in the town." Note that the flag is hanging backwards on the wall.

Five

Transportation, Overcoming Isolation

Cheap, efficient transportation was vital to the development of the economy of Summit County. An adequate transportation system meant the difference between growth and stagnation for the towns, mines, and ranches. Without it, ore, agricultural products, and timber would not reach markets—residents of the county would not receive the things they needed for daily living. As soon as the mineral wealth of the county was confirmed, roads became a high priority. The building and maintenance of those roads was important. Many routes served multiple purposes. Footpaths for the Utes became wagon roads. Some wagon roads were used by the railroads for their rights-of-way.

To assure its prominence economically, every town wanted daily stage service. Owners of passenger stages faced many difficulties: rocky, dusty roads; snow, ice, and cold; high costs for feed and equipment repair; and accidents.

Maintaining the roads was so critical that all able-bodied men were expected to help with road maintenance a few days each year. If unable to help, that person was levied a road tax of a few dollars a year.

The huge tonnage of goods entering and ore leaving the county brought the railroads, although their desired destination was Leadville, not Summit County. William Jackson Palmer, the president of the Denver, Rio Grande Railroad, opined that a population engaged in mining is the most profitable by far for a railroad. The county was served by two narrow-gauge railroads: the Denver, Rio Grande and the Denver, South Park, and Pacific. Their fortunes were tied to the mining economy; when it died, so did the railroads, although it must be recognized that the railroads had a stranglehold on the mining economy from the very beginning because of high transportation rates.

A central theme to Summit County's history has been movement—the movement of people, goods, and ideas. For centuries, the valleys and passes of the county have been conduits for Utes, miners, ranchers, merchants, and others carrying goods into and out of the county. The recreational economy in place today promises to continue this tradition.

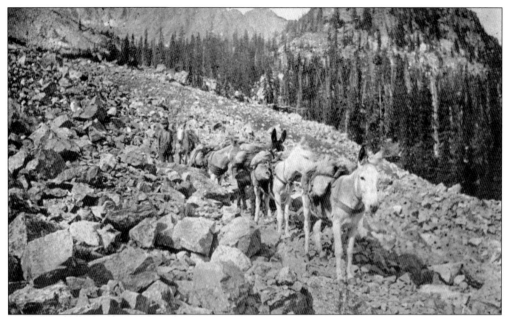

BURRO AND MULE TRAINS. Pack trains consisting of as many as 100 burros and/or mules hauled merchandise and ore over the steep hills and narrow trails. Guided by one or two men and several dogs, the burros carried 100 pounds and the larger mules 300 pounds. Winter was particularly difficult for these animals. Snow, ice, and wind taxed their ability to negotiate the steep, narrow trails.

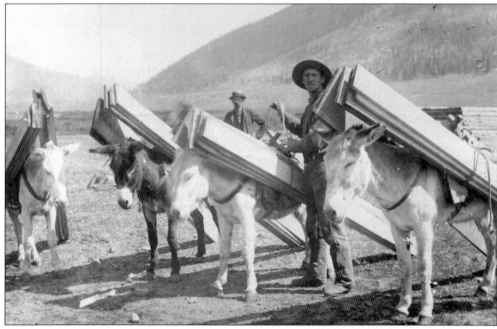

ANIMAL TRANSPORT. Although transporting ore by wagon was cheaper, pack trains were able to negotiate trails too narrow and steep for wide, heavy wagons. Spring, summer, and fall were the busy seasons for pack trains. For obvious reasons, miners ordered lumber several inches longer than they needed if the boards brought by pack train were dragged along the ground.

ROAD BUILDING IN THE 1800s. Road building was a difficult task. Trees had to be cut, boulders and stumps removed, and holes filled. Streams were diverted and bridges built. Melting snow in the spring washed out many roads. Fires burned wooden bridges. The maintenance of roads never ended for the streets commissioner in a mining town.

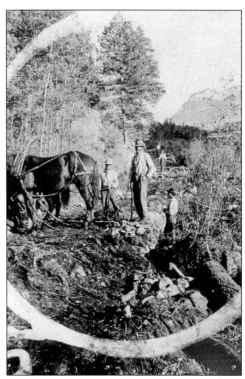

WET IN SPRING, DUSTY IN SUMMER. The weather had a big influence on the roads of the county. Storms washed out bridges and sent trees crashing onto roadways. Ice made the roads treacherous for wagons and carriages. Because of this influence, the newspaper editor often wrote interesting remarks about weather conditions: the weather continues, the snow is rotting, and rains are frequent and of a damp character.

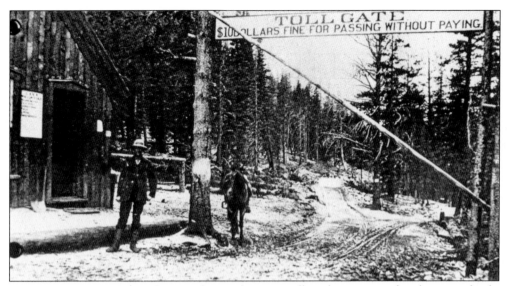

TOLL GATE. Many roads in Summit County began as toll roads constructed with private funds. While these roads provided somewhat better roadbeds for carrying ore, merchandise, and passengers, merchants and others preferred to pay no tolls. Therefore these roads were not permanent features on the landscape. Abandoned toll roads often became free roads for county residents. This road over Argentine Pass operated as a toll road until 1883.

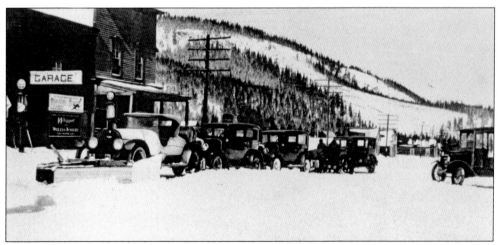

INGENUITY AT WORK. Knowing the railroad's ongoing efforts to abandon the line, residents worked hard to keep roads open during the winter. Some resourceful folks in Dillon made a plow of sheet iron attached to heavy planks and bolted it to the front of a car that was pushed by five other automobiles chained together. Each car had heavy wooden bumpers on the front and back.

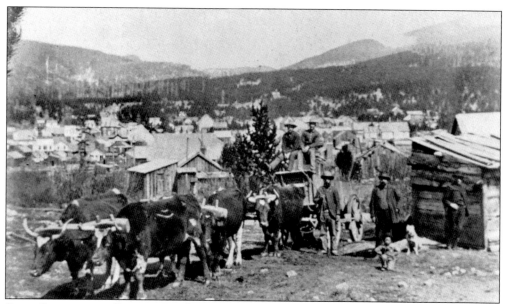

SLOW, STEADY, AND STRONG. Roads to and from mine sites could be very treacherous. Elevations changed rapidly. Only the strongest of animals could prevent the wagons from overturning on the way down. Only the strongest could haul heavy loads up the steep grades. With loads of ore and supplies sometimes reaching several tons, oxen were usually the chosen method of navigating the steep slopes.

DENVER, SOUTH PARK, AND PACIFIC NARROW GAUGE. Narrow-gauge tracks had advantages. Sharp turns so necessary in the mountains were possible with less blasting. Shorter ties saved money, as did the smaller, lighter engines and cars. Narrow-gauge track could be laid faster. Track men earned $2.25 per day in 1882. Rock men earned $2.50. Room and board cost $5 per week.

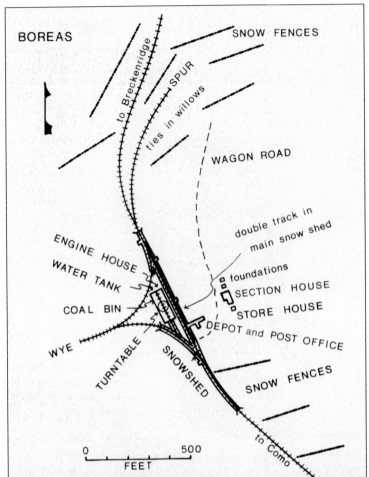

BOREAS

SNOW FENCES

to Breckenridge

SPUR

ties in willows

WAGON ROAD

double track in
main snow shed

foundations

ENGINE HOUSE

WATER TANK

SECTION HOUSE

COAL BIN

STORE HOUSE

WYE

DEPOT and POST OFFICE

TURNTABLE

SNOWSHED

SNOW FENCES

to Como

0 500
FEET

BOREAS PASS. At an elevation of 11,481 feet, the town with its residences and railroad facilities endured the constantly blowing wind. The town had a depot, storehouse, telegraph house, section house, and residences east of the tracks, and a stone engine house with coal bin, spring-fed water tank, and turntable on the west.

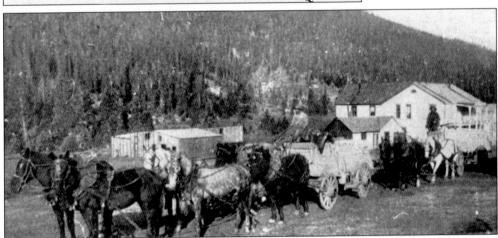

HAULING ORE FROM MONTEZUMA. Wagons such as these could carry as much as 9,000 pounds and hauled ore to nearby mills and concentrators. While pack trains could negotiate trails too narrow for these heavy wagons pulled by oxen, the wagons were generally cheaper to operate. The Rocky Mountain House is on the right, while the Wave Assay Office is on the left.

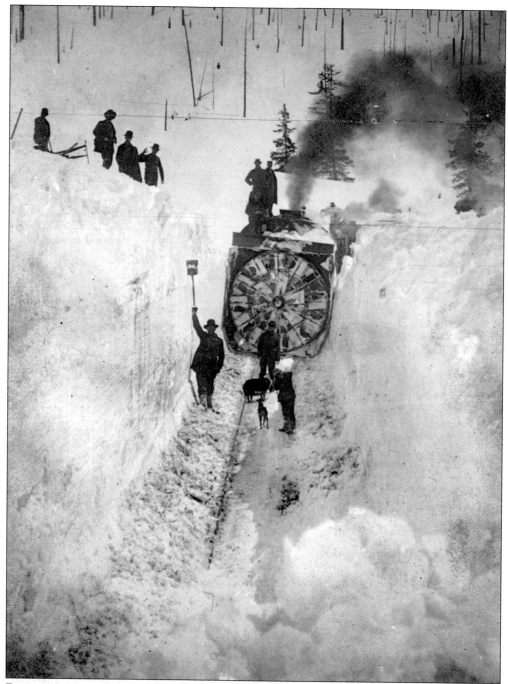

Rotary Snowplow. Snow was so deep over Boreas Pass and in the Ten Mile Canyon that the railroads used rotary plows to clear the tracks. Working like a modern snow blower, the rotary plow chewed its way through a drift, throwing the snow up to 30 feet. The plow was powered by a coal-fired boiler. Because it was not self-propelled, the rotary was pushed by four to six engines.

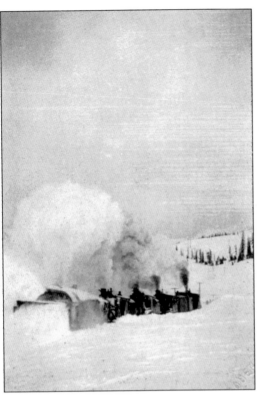

HEAVY SNOW. Behind this rotary snowplow heading toward Boreas Pass were three engines pushing the plow. The fourth engine was turned backwards to pull out the rotary if it should become stuck. Between the third and fourth engines was a car that housed men whose job was to shovel down to the rotary when the drifts towered high above it.

SNOWSHED. In order to load and unload people and freight more easily, a snowshed was built over the track at Boreas Pass. This meant loading and unloading in relative darkness. Sparks from the trains often set the shed ablaze. One fire in December 1903, which burned the shed and ties, created enough heat to twist the rails. At one point, the snowshed covered 997 feet of track.

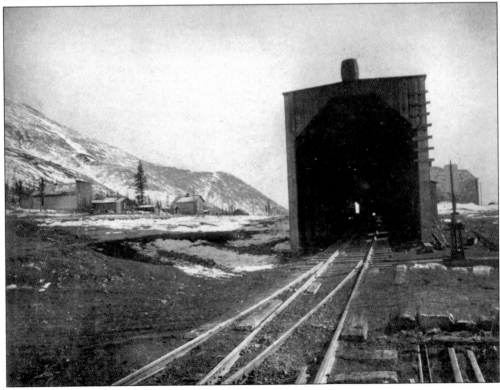

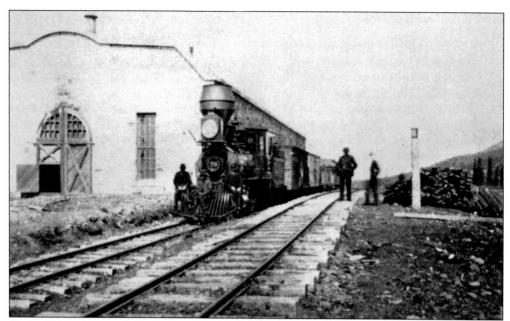

STONE ENGINE HOUSE. To service its engines at the top of the pass, the Denver, South Park, and Pacific Railroad built a stone engine house with a spring-fed water tank, coal bin, and turntable to reverse the direction of the helper engines required on some trips. Beginning at Como with an elevation of 9,796 feet, the engines crossed Boreas Pass at 11,481 feet and dropped to 9,577 feet in Breckenridge.

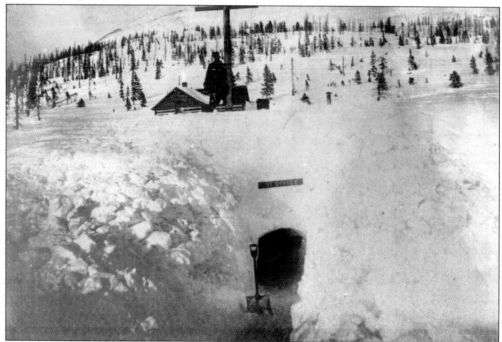

POST OFFICE ENTRANCE AT BOREAS PASS. The town of Boreas, constructed in 1882 by the railroad and named for the North Wind, was the highest rail station in the United States. In winter, people entered the post office through a snow tunnel.

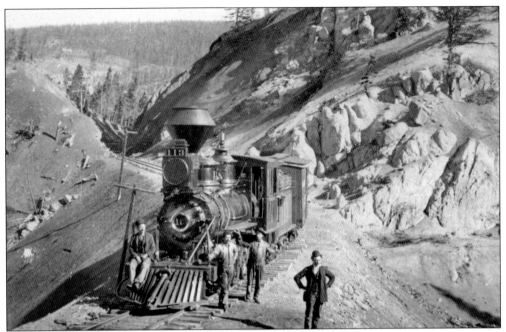

ENGINE NO. 113 AT ROCKY POINT. This engine, built in 1884 and weighing 58,300 pounds, hauled freight and passengers over Boreas Pass. Still working in 1938, it was scrapped in December of that year. Maximum speeds in the mid-1880s for passenger trains were less than 22 miles per hour in the county and less than 12 miles per hour for freight trains over Boreas Pass.

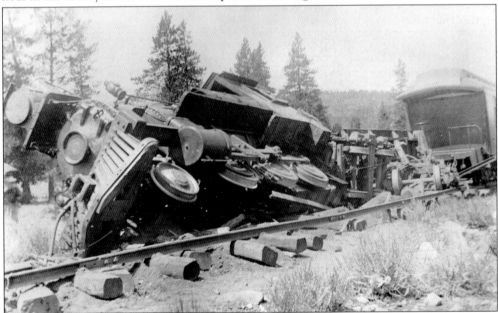

OOPS! Accidents happened. Before trains began the descent from Boreas Pass, brakemen set the brakes so that the trains would not descend at more than five miles per hour. To stop a train moving at that speed, enough braking power to actually lift the train from the tracks would be needed. A train descending a 4.5-percent grade would double its speed every 15 seconds unless checked by strong brakes.

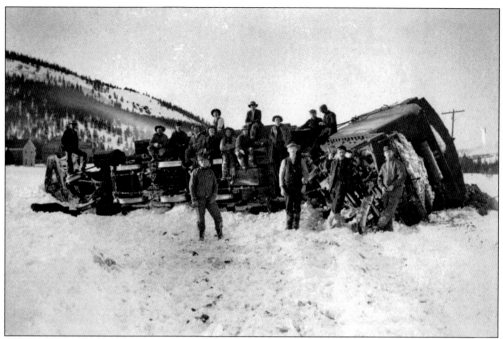

UNINTENDED RESTING PLACE. When accidents happened, the railroad brought heavy equipment to lift the engine and cars back onto the track. Workers replaced damaged track. Sometimes an engine derailed when ice from a leaking water tank covered the tracks. Flanges on the front of the engine attempted to scrape ice from the tracks as the engine moved along. In winter, engines carried sand to increase traction on icy rails.

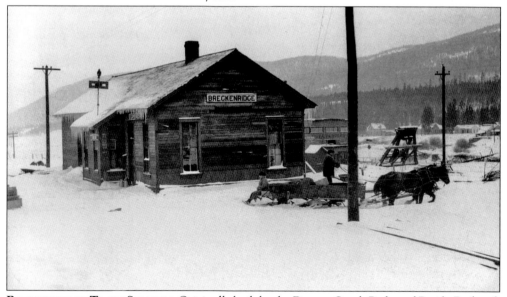

BRECKENRIDGE TRAIN STATION. Originally built by the Denver, South Park, and Pacific Railroad, the tracks ran on the west side of the Blue River. Typical of western mining towns, mining-related buildings such as mills, smelters, sawmills, storage sheds, coal bins, and warehouses, as well as the depot, were built along the tracks. These structures would be on the opposite side of the river from the main businesses of town.

BLOCKADE OF 1898–1899. The winter of 1899 was particularly difficult for the railroad and people of Summit County. The rotary snowplow, pushed by seven engines, was stuck on Barney Ford Hill for 78 days, from February 6 until April 24. By the time men from town were able to shovel open a road to Como, food was in short supply in Breckenridge. Hay was almost gone. Mines were laying off workers because ores could not be shipped. Enough supplies were able to reach Breckenridge by sled to prevent shortages, but prices almost doubled at a time when many were out of work. People throughout the county who were dependent on the railroad for supplies faced severe shortages. Twelve thousand pounds of mail for Summit County residents had accumulated in Como on the other side of Boreas Pass before it could be delivered.

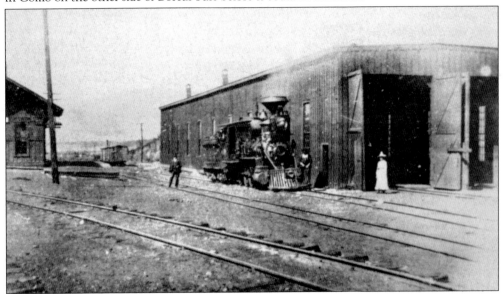

DICKEY. Dickey, now beneath the water of Lake Dillon, functioned as a switching point leading to Dillon and Keystone for the Denver, South Park, and Pacific. The railroad built a coaling station, a depot, a 47,500-gallon water tank, a coal chute, and sidetracks for 188 cars. There was a "wye," as well as a roundhouse with stalls to hold three helper engines needed for the trip over Boreas Pass.

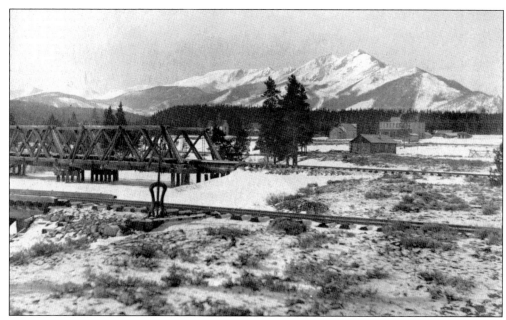

RAILROADS IN DILLON. Prior to 1900, Dillon moved twice. When the Denver, Rio Grande Railroad arrived in November 1882, the town moved from its original spot along the Snake River to a site between the Blue River and Ten Mile Creek. A month later when the Denver, South Park, and Pacific Railroad arrived, the town moved west of the Ten Mile Creek to embrace both railroads. The Hamilton Hotel is in the background.

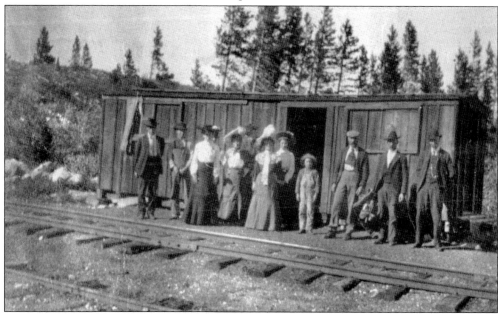

THE 1882 PASSENGER DEPOT IN FRISCO. Passengers waited beside the narrow-gauge tracks for the often-delayed trains. Washed-out bridges, accidents, mud slides, icy tracks, flooding, and avalanches all impacted the schedule. Merchants complained about tardy deliveries. Joe Reeder, a saloon keeper in Breckenridge, planned to lay in a full winter's supply of beer before the "retarded" railroads allowed the beer to freeze in transit.

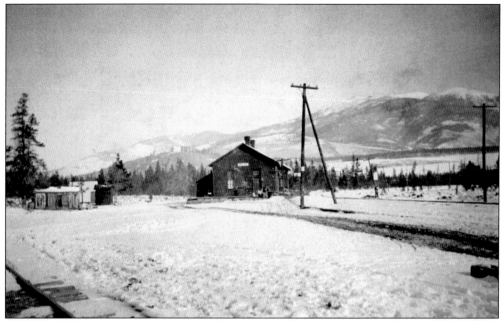

COLORADO AND SOUTHERN DEPOT IN DILLON. Dillon was served by both narrow-gauge railroads—the Denver, Rio Grande and the Denver, South Park, and Pacific, later the Colorado and Southern. Before the automobile, the railroads were the lifeblood of the county, carrying freight, coal, ore, and passengers. However, they were not the panacea people expected. High rates, irregular schedules, unclean cars, and inefficient engines were reoccurring problems.

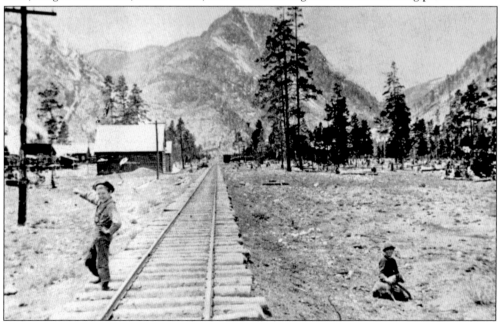

RIGHT-OF-WAY IN FRISCO. Hoping to take advantage of its location along the railroad, Frisco town leaders donated land to the Denver, Rio Grande for its right-of-way through town. The railroad intended to link the mines in the Ten Mile Canyon with smelters in Denver and Leadville. Citing lagging profits and duplicated services, the railroad ceased operations in February 1911.

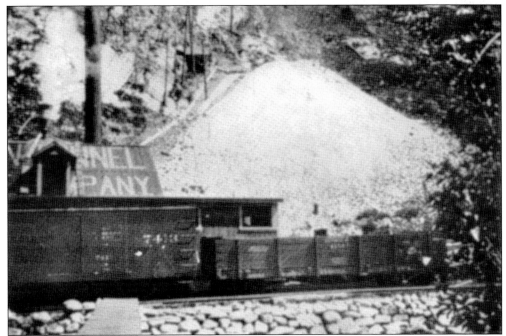

THE TRANSPORTATION ADVANTAGE. A six-car spur of the Denver, South Park, and Pacific Railroad, later the Colorado and Southern, was built directly in front of the dump of the King Solomon Mine. This gave the mine a distinct advantage when it came to shipping ore to mills and smelters in Leadville and Denver.

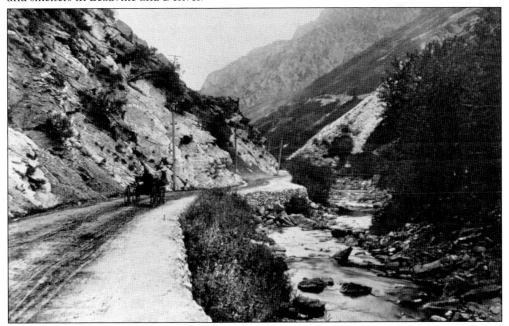

TEN MILE CANYON. The canyon held two railroads, one stream, and one wagon road. Because it was there first, the Denver, Rio Grande tried to prevent the Denver, South Park from building in the canyon. A judge ruled that the Denver, South Park could proceed as long as its facilities were not closer than 50 feet to the center of the Denver, Rio Grande right-of-way.

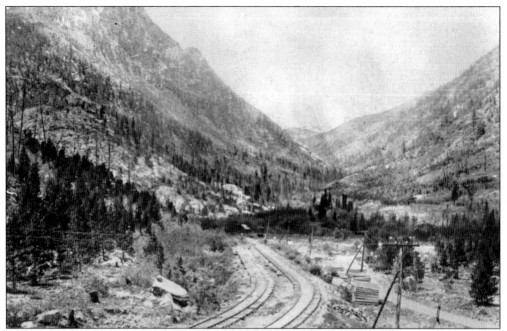

DENVER, SOUTH PARK TRACK AND SPUR. The Denver, South Park's tracks were laid along the eastern side of the Ten Mile Canyon. Because none of the facilities of the railroad could be closer than 50 feet to the center of the Denver, Rio Grande right-of-way, one of these tracks is a spur serving the mines found on the east side of the canyon.

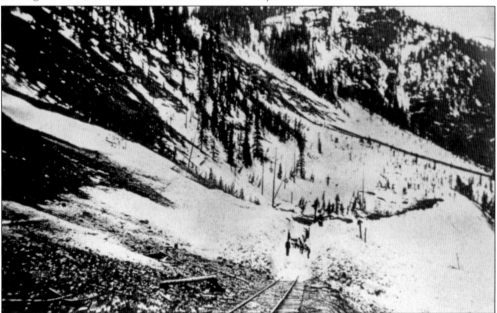

AVALANCHE IN TEN MILE CANYON. Winter was particularly difficult for the railroads. Bitter cold, howling wind, and blowing snow created hazardous traveling conditions. Avalanches, often caused by rumbling engines and shrill whistles, buried the tracks in snow, rocks, and uprooted trees. When clearing an avalanche required dynamite, the tracks had to be replaced before the railroad could resume service.

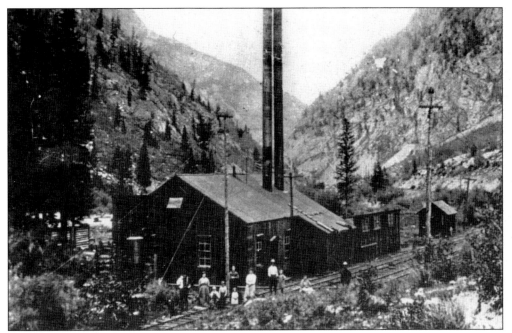

CURTIN IN 1908. Curtin, named for a section boss who supervised 160 men laying track in the Ten Mile Canyon, served numerous mines in the canyon. At the stop there was a depot, a section house, and a blacksmith shop. Pictured is the powerhouse of the nearby Mary Verna Mine, located along the Colorado and Southern tracks.

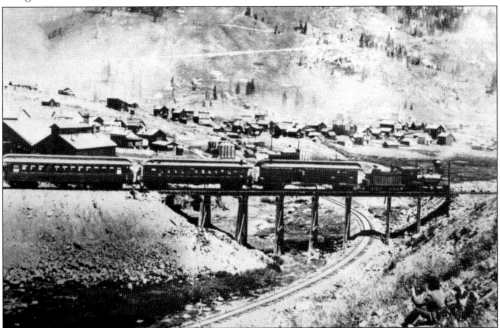

TRESTLE IN ROBINSON. Where the width of the Ten Mile Canyon was too narrow to maintain a distance of 50 feet from the Denver, Rio Grande right-of-way, a judge ruled that the Denver, South Park could build two crossings over the Denver, Rio Grande tracks on trestles. To slow construction, the Denver, Rio Grande stationed locomotives at the construction sites.

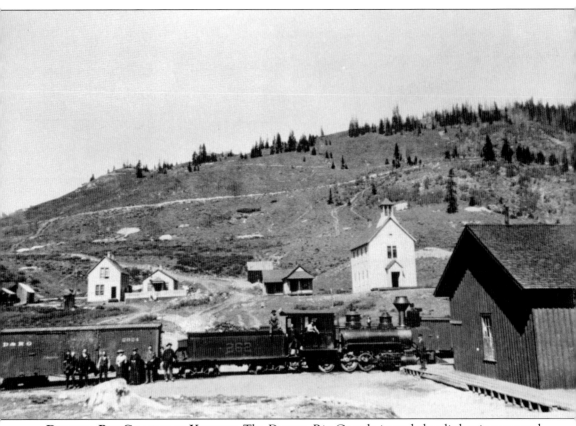

DENVER, RIO GRANDE IN KOKOMO. The Denver, Rio Grande intended to link mines around Kokomo with smelters in Leadville and Denver. Because it was the first to build in the canyon, it chose the best route along the western side of the canyon. The Denver, South Park, and Pacific had to build its tracks along the eastern side of the canyon where construction was more difficult.

Six

AGRICULTURE ALONG THE LOWER BLUE RIVER

Ranching began in Summit County when herdsmen drove their cattle and sheep over the Continental Divide in summer to graze on the same lush grasses covering the valleys and hillsides that had provided food for the buffalo for centuries. Products from the ranches went directly to the mining towns and camps.

Ranches tended to be large because of the many acres required to raise sufficient winter feed for the animals. Summer grazing occurred mainly on national forest land. Each ranch consisted of fields for crops and winter grazing, as well as corrals, barns, a house, and a variety of small buildings. There was also a garden for growing those crops that matured in the short, frost-free season. Crops included carrots, turnips, cauliflower, radishes, mountain head lettuce, spinach, peas, cabbage, potatoes, and onions.

Hay was a very important crop used for winter feed. Haying began in August and might continue until October if snow or heavy rain delayed the harvest. The fall roundup followed haying. Calves were branded, and yearlings, calves, and older cattle were culled for shipment to Denver. Ranchers conducted another roundup in the spring, mainly for branding the newborn calves.

Normally, few cattle found immediate markets in the county. Instead, those sent to the stockyards in Denver were "finished," meaning they were fed corn to increase their weight and meat quality. From there, the meat was shipped to distant markets.

The county produced more than just cattle. Sheep were sent by rail from several depots in the county, including Wheeler (now Copper Mountain), Montezuma, Dillon, and Breckenridge.

The biggest problem facing ranchers was not the weather; it was the fluctuating prices received for their products and the high cost of shipping charged by the railroads.

Today much of the agricultural landscape is gone. Most of the remaining ranches are found along the lower Blue River Valley where the winters are less severe and the pressures from land developers not as great.

DICHOTOMY. Authors have identified many dichotomies on the mining and agricultural landscapes. Clustered buildings under the vast blue sky was just one of them. Meadows and grazing land surrounding the clustered buildings typified ranches stretching along the lower Blue River Valley from Dillon to the northern end of the county.

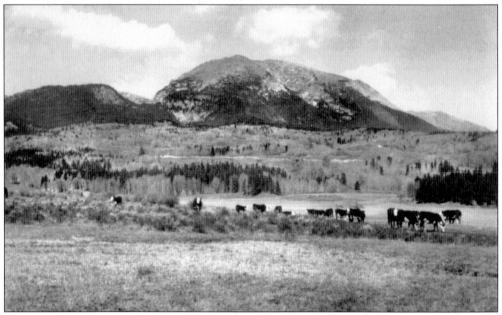

HOWARD AND LURA BELLE GIBERSON'S RANCH. Cattle grazed the grasses in the meadows on the Giberson ranch that extended from the slopes of Buffalo Mountain to land now under the water of Dillon Reservoir. Although there were exceptions, few cattle were brought into the county to maintain or increase herd size. Usually, calves born each spring replaced those sent to market.

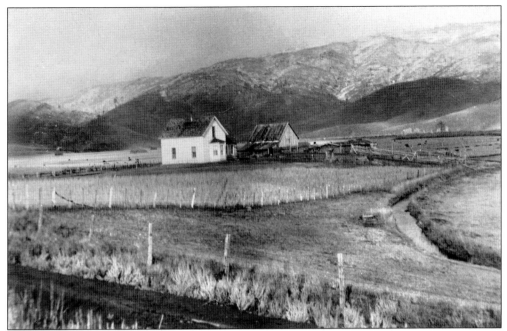

RANCH ON LOWER BLUE RIVER. Ranches and their products were a welcome addition to the mining landscape. The Homestead Act of 1862 allowed a rancher to claim a quarter section of the public domain for a $10 filing fee. Irrigation systems brought water for raising hay and other forage for winter feed so that cattle could remain year-round. Water ditches drained and irrigated pastures.

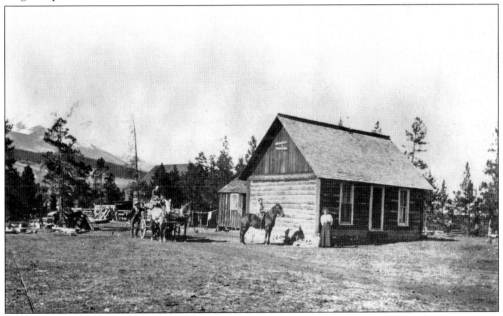

KEENER RANCH NORTH OF DILLON. Everyone living on a ranch shared the chores. Women maintained the home, doing the cooking, washing, cleaning, and sewing. They carried water and tended the family garden. Daughters assumed responsibility for some of these chores as soon as they were able, while sons helped with the ranching.

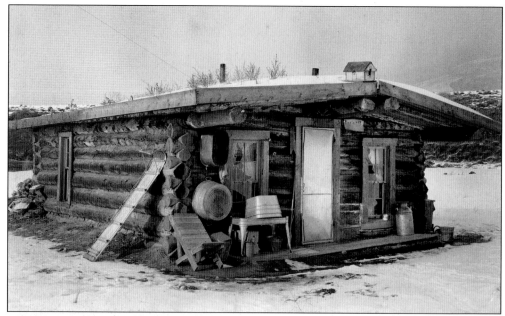

HOME SWEET HOME. The walls of one-story log cabins were generally eight logs high. The spaces between the logs were chinked with mud, clay, rocks, or paper to keep out the wind, snow, and rain. The type of corner notching often told the ethnicity of the builder. Timbers running the length of the building supported the roof, frequently covered with sod as a substitute for wooden shingles.

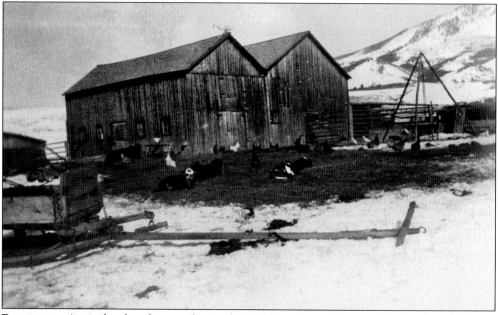

BARNYARD. Animals other than cattle populated the ranches of Summit County. Sheep, horses, and a few mules shared pasture lands and barnyards with swine and poultry. Chickens and perhaps a few turkeys and ducks provided meat and eggs. The cattle, mainly Herefords and, later, Angus, were raised for cash. When snow covered the ground, sleds were the easiest means of transportation.

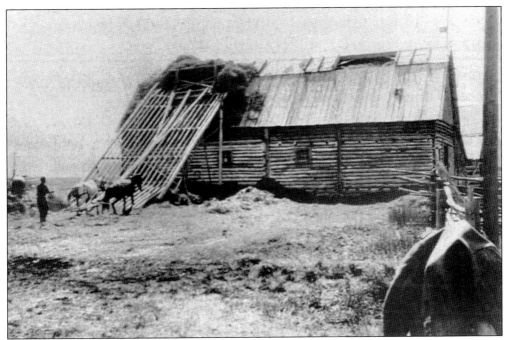

HAY STACKER. Ranchers used a wooden plunger to push the grasses up the incline and into the barn through an opening at the peak of the roof. Note the round log construction and the steeply sloping roof of the Rice barn in Summit Cove. Ranchers used barns for storing forage and sheltering dairy herds and horses, but not beef cattle. Two- or three-sided sheds provided shelter for them in winter.

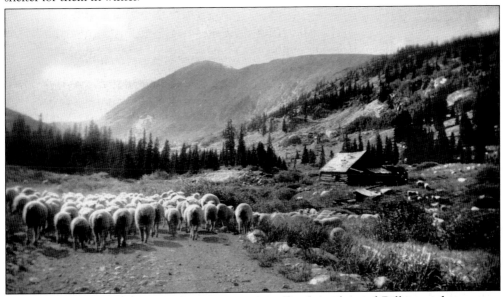

SHEEP AND WOOL. Sheep were frequent visitors to Breckenridge and Dillon on their way to the pasture, market, or railroad depot. Two ranchers drove 4,800 sheep through Breckenridge in 1883 on the way to Green Mountain. Their two ranches had over 16,000 sheep, which produced 75,000 pounds of wool per year. The newspaper editor predicted millions of sheep in Summit County in the near future.

RANCH HAND IN CHAPS. Ranch hands, including cowboys, were integral to the operation of the ranches along the lower Blue River Valley. At roundup in spring and fall, the cowboys herded the cattle that had been grazing on national forest land to the corrals for branding. The rest of the year, the ranch hands helped with a variety of chores.

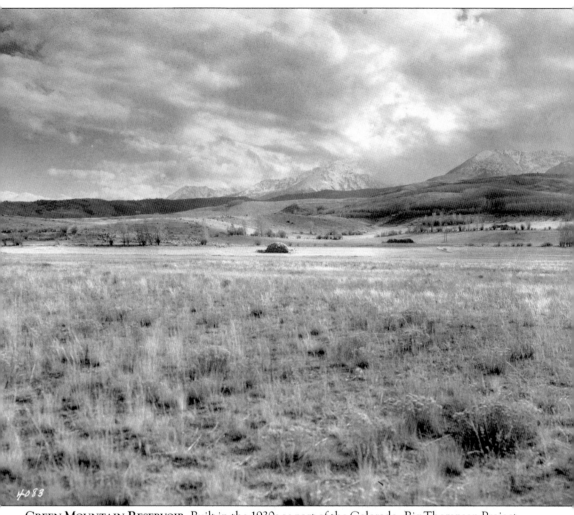

GREEN MOUNTAIN RESERVOIR. Built in the 1930s as part of the Colorado–Big Thompson Project, the Green Mountain Reservoir flooded ranches, such as this one that had been producing cattle, sheep, hay, and timothy since the 1860s. Winter feed grown on valley bottoms was placed in enclosures until it was needed. The fence protected the feed from hungry animals.

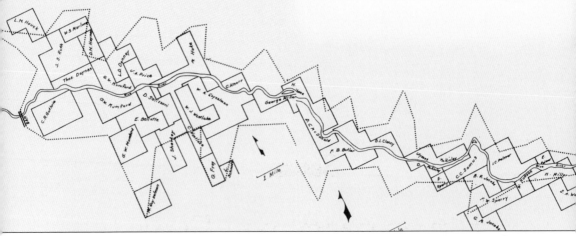

GREEN MOUNTAIN RESERVOIR. Originally called Mammoth Reservoir, Green Mountain Reservoir inundated ranches along the lower Blue River. The dotted line indicates the shoreline of the reservoir. In 1906, the Lee, Laskey, Knorr, and Mumford ranches filled 12 railroad cars with 225 head of cattle. In 1915, some 235 head filling 13 railroad cars were sent to Kansas City from the Ward, Hamilton, Lindstrom, Lund, Gould, and Forslund ranches.

Seven

RECREATION, FUN, AND RELAXATION

Recreational activities provided wholesome endeavors to occupy the minds of young people and keep young men out of saloons and bordellos. Many types of outdoor activities were available in summer and winter.

The cold weather meant ice-skating was a popular winter activity. A 60-foot tent erected over the frozen Blue River provided sheltered skating in 1883. Clip-on skates held in place by straps arrived from Denver. Local musical groups played during the evening. "Snowshoeing" (today's skiing) for recreation was a favorite of many. When ski jumping was introduced in 1910, it became quite a popular sport.

In 1883, the newspaper editor noted that football in the streets was all the rage.

Baseball was the most popular summertime sport with teams from Montezuma, Dillon, Frisco, and Breckenridge traveling throughout the county for games. The *Summit County Journal* reported on each one in great detail and in very vivid language. In the 1920s, when the mining economy was depressed, the newspaper editor devoted more front-page space to baseball news than to mining activities.

Cycling clubs sponsored excursions for men, women, and children. The groups rode throughout the county. Fishing, hiking, and hunting occupied the free time of many residents. Picnics were favorite activities for men, women, and children.

Even the railroads offered outdoor recreational activities for county residents. The newspapers carried advertisements offering excursions through the Ten Mile Canyon to Leadville for very low rates.

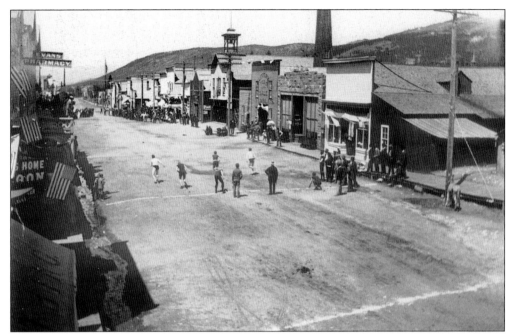

FOOT RACE ON MAIN STREET. With referees and spectators watching, several young men begin a race that will take them past Finding's Hardware Store with its stone front, Radigan's Livery Stable, and the fire hall with its hose-drying tower. The flags indicate that the race might have occurred on the Fourth of July, perhaps the biggest holiday of the year in Summit County.

BICYCLES IN BRECKENRIDGE. Ready for a festive occasion, these bicyclists stand proudly with their decorated bicycles at the corner of Main Street and Adams Avenue around 1900. Men, women, and children decorated bicycles for holiday parades. Clubs sponsored outings throughout the county for members. Cycling was one of many forms of recreation that could be enjoyed when the snow melted from streets and roads.

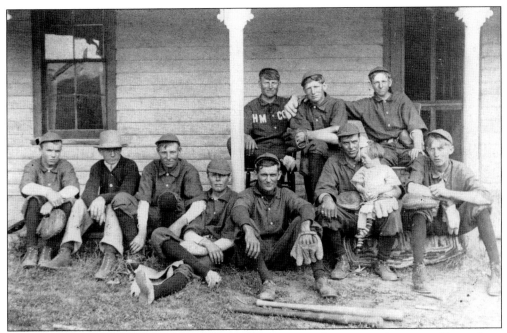

SLATE CREEK BASEBALL TEAM. Baseball was the most popular summertime sport. Teams from Dillon, Montezuma, Breckenridge, Slate Creek, and Frisco traveled throughout the county and across county boundaries for games. The newspaper reported on each one. Headlines screamed, "Dillon crushes Breckenridge," "Slate Creek mauls Frisco," and "Montezuma murders Alma."

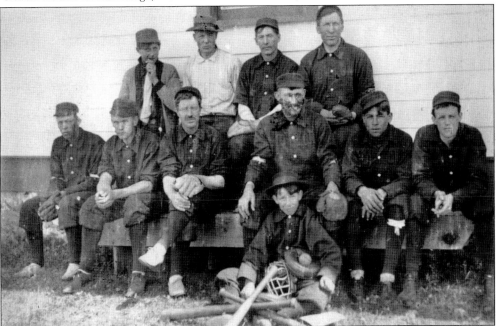

DILLON BASEBALL TEAM. Baseball games were well attended, and the competition was fierce. One of the biggest fans of the game was Miss Dixie, an aging prostitute in Montezuma. She attended the games in her colorful dress and rooted heartily for the Montezuma team, always careful to watch and cheer from a spot away from the other town residents.

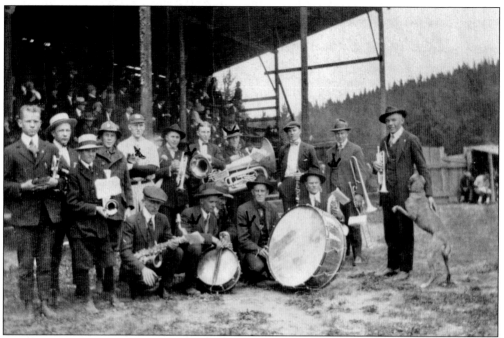

ENTERTAINMENT AT THE BASEBALL GAMES. The Breckenridge Band entertained the spectators at the baseball games in town. Open to men and boys of all ages, the bands in the various towns supported their home team. In this photograph, one of the band members doubles as a member of the baseball team.

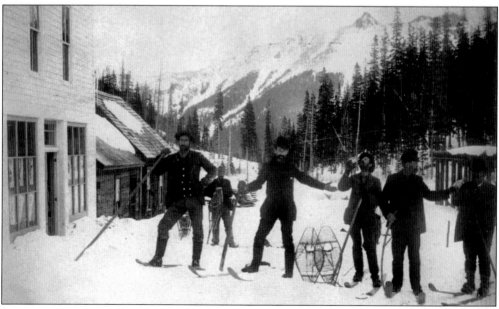

SNOWSHOEING. Snowshoes, today's skis, were used to slide down a mountain. Indian feet or webs, today's snowshoes, were needed on uphill climbs. Both were used on an outing. To fortify themselves, the men pass bottles of liquid refreshment. Snowshoers carried one pole. To stop, the person placed the pole between his or her legs and sat on the pole. To turn, the person used the pole as a rudder.

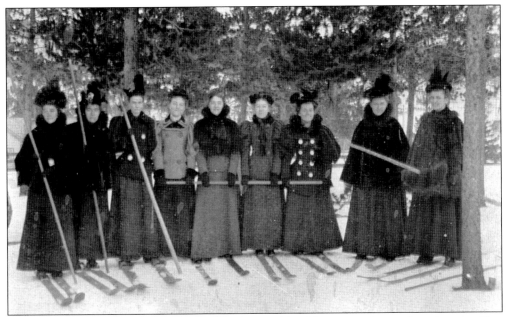

WHO IS WITHOUT SKIS? Count the number of pairs of skis. Now count the number of women. Can you determine which one is without skis? The woman fourth from the left is Agnes Silverthorn Finding Miner, granddaughter of Agnes Ralston Silverthorn and Marshel Silverthorn of Breckenridge. Her father owned Finding's Hardware Store in Breckenridge. These women with their long skis and single pole were enjoying an outing "snowshoeing."

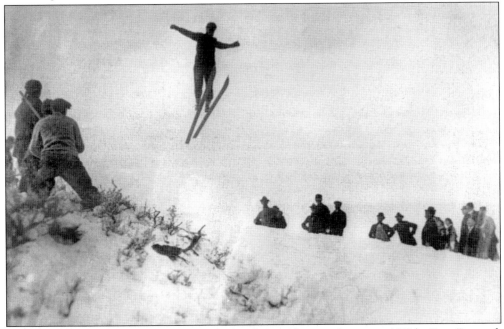

SKI JUMPING. Ski jumping was introduced to residents of Summit County in 1910 by Peter Prestrud, a Norwegian living in Frisco. It soon became a favorite sport among the men and young boys. On the Dillon ski jump, Anders Haugen, another Norwegian, set a world record in 1919 with a distance of 213 feet. A year later, he broke his own record with a jump of 214 feet.

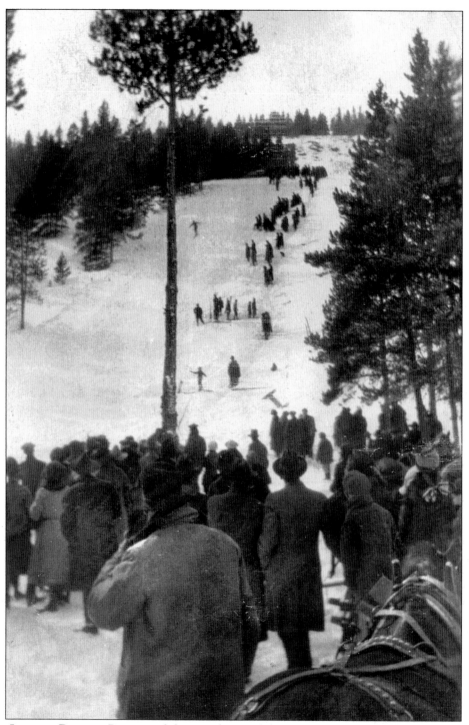

SKI JUMP IN DILLON. Because of the popularity of ski jumping, many small ski jumps were built around Dillon and Frisco. The largest was the jump on Lake Hill just to the west of old Dillon. People came from throughout the area to see the competitions. The thin atmosphere at 9,000 feet helped the "flyers" achieve great distances on their jumps.

EPILOGUE

Much has happened since the time period covered in this book. The search for "white gold" and the development of the winter and summer recreational landscapes have supplanted the search for mineral wealth and the devastation produced by that pursuit.

Although men, women, and children donned skis in the post–World War I years, it was after World War II, when men trained at Camp Hale returned to Colorado, that modern downhill skiing arrived in Summit County. Arapahoe Basin, the first large ski complex in the county, opened in 1945 along the Continental Divide. Peak 8, just west of the quiet town of Breckenridge, opened in December 1961. Now known as the Breckenridge Ski Resort, it has expanded both north and south along the Ten Mile Range with runs stretching across peaks 7 through 10. A third ski resort was the dream of Max Dercum as early as the mid-1940s. Even while he helped develop Arapahoe Basin, he envisioned a ski area on Keystone Mountain and celebrated its opening in November 1970. The fourth ski complex in the county, Copper Mountain, opened in 1971. The philosophy of the developers was a simple one: the ecosystem is a single, closed system. Nature should be duplicated whenever possible. Trees were considered a "timber harvest." The Environmental Sawmill cut the timber for firewood, and the Thick and Thin Lumber Company of Copper Mountain sold it on the local market. Four million tons of sand and gravel, recovered from the rechanneling of the Ten Mile Creek, were used by the Pretty Lumpy Concrete Company of Copper Mountain to make concrete for a variety of projects.

But winter is not the only season offering recreational opportunities. In 1963, the Denver Water Board began water storage behind its newly constructed Dillon Dam. Taking advantage of the confluence of the Blue River, Ten Mile Creek, and Snake River at old Dillon, the Denver Water Board built the 231-foot-tall, 5,888-foot-long dam using 12 million tons of fill. Part of the system of reservoirs that supplies water to the city of Denver, Lake Dillon holds over 257,304 acre feet of the precious liquid. The water flows under the Continental Divide through a 23.3-mile-long tunnel to Grant. Beneath the water of the reservoir are the first three town sites of Dillon.

At the northern end of the county are Green Mountain Dam and Reservoir, part of the Colorado–Big Thompson project. Construction on the earth- and rock-fill dam began in 1938 and was completed in 1943. The dam is 1,150 feet long and 309 feet high. When full, the reservoir holds over 153,000 acre feet of water. Its 2,125-acre-foot surface buried many of the ranches that lined the lower Blue River Valley.

Both reservoirs provide recreational opportunities for county residents and visitors.

Summer, winter—yellow gold, white gold—blue skies or cloudy—19th century, 20th, or the 21st—the landscape of Summit County still offers stories for those who care to read them.

BIBLIOGRAPHY

Ellis, Erl. H. *The Gold Dredging Boats around Breckenridge, Colorado.* Boulder, CO: Johnson Publishing Company, 1967.

Fiester, Mark. *Blasted Beloved Breckenridge.* Boulder, CO: Pruett Publishing Company, 1973.

Mather, Sandra F. *Behind Swinging Doors, the Saloons of Breckenridge and Summit County, Colorado 1859–1900.* Breckenridge, CO: The Town of Breckenridge, 2003.

———. *Dillon, Denver and the Dam.* Breckenridge, CO: Summit Historical Society, 1994, 1998.

Nicholls, Maureen. *Gold Pan Mining Company and Shops.* Breckenridge, CO: Quandary Press, 1994.

Poor, M. C. *Denver, South Park and Pacific, Memorial Edition.* Denver, CO: World Press, 1976.

Pritchard (Mather), Sandra F. *Men, Mining, and Machines, Hardrock Mining in Summit County, Colorado.* Breckenridge, CO: Summit Historical Society, 1996.

———. *Roadside Summit, Part II, The Human Landscape.* Breckenridge, CO: Summit Historical Society, 1992.

Speas, Sam, as told by Margaret Coel. *Goin' Railroading, a Century on the Colorado High Iron.* Boulder, CO: Pruett Publishing Company, 1985.

INDEX

Ancient Free and Accepted Masons, 90
Breckenridge, 38–59, 83–85
Briggle, Kate, 78
Boreas Pass, 98
Brooks-Snider Mill, 27
Bruch, Fred, 59
Bruch, Minnie, 50
Carter, Edwin, 74
Dillon, 28, 29, 83–85
dredges, 28–33
Dyer, John Lewis, 76
Engle, George, 50, 51
Engle, Peter, 50, 51
Ford, Barney Lancelot, 75
Frisco, 66, 67
Gaymon, Oren, 80
giants or monitors, 14
Gold Pan Shops, 42
Grand Army of the Republic, 92
Great Flume, 18
Green Mountain Reservoir, 117, 118
Independent Order of Odd Fellows, 91
Kaiser, Christ, 51
King Solomon Mill, 24
Kokomo-Recen, 68–71, 82
Leyner's Hotel, 90
Myers, James H. Jr., 78
Myers, Lula, 78

Montezuma, 25–28, 64, 65
railroads, 97, 110
recreation, 120, 124
ranching/agriculture, 112–116
Revett, Ben Stanley, 79
roads, 95, 96
rotary snowplow, 99
Ryan, Pug, 77
saloons, 46–48, 65
schools, 83–87
Silverthorn, Marshel, 53
Silverthorn, Agnes Ralston, 53
ski jumping, 123, 124
Slate Creek School, 87
sluices, 16
snow tunnels, 58
St. John the Baptist Episcopal Church, 35
St. Mary's Catholic Church, 57
Sts. John, 35
Summit County Courthouse, 56
Tiger, 71, 72
Tom's Baby, 26
Tonopah Dredge, 32
Torkington's Barber Shop, 52
Ute Indians, 9–12
water ditches, 19
Wellington Mill, 24

ACROSS AMERICA, PEOPLE ARE DISCOVERING SOMETHING WONDERFUL. *THEIR HERITAGE.*

Arcadia Publishing is the leading local history publisher in the United States. With more than 4,000 titles in print and hundreds of new titles released every year, Arcadia has extensive specialized experience chronicling the history of communities and celebrating America's hidden stories, bringing to life the people, places, and events from the past. To discover the history of other communities across the nation, please visit:

www.arcadiapublishing.com

Customized search tools allow you to find regional history books about the town where you grew up, the cities where your friends and family live, the town where your parents met, or even that retirement spot you've been dreaming about.